W9-CLI-981

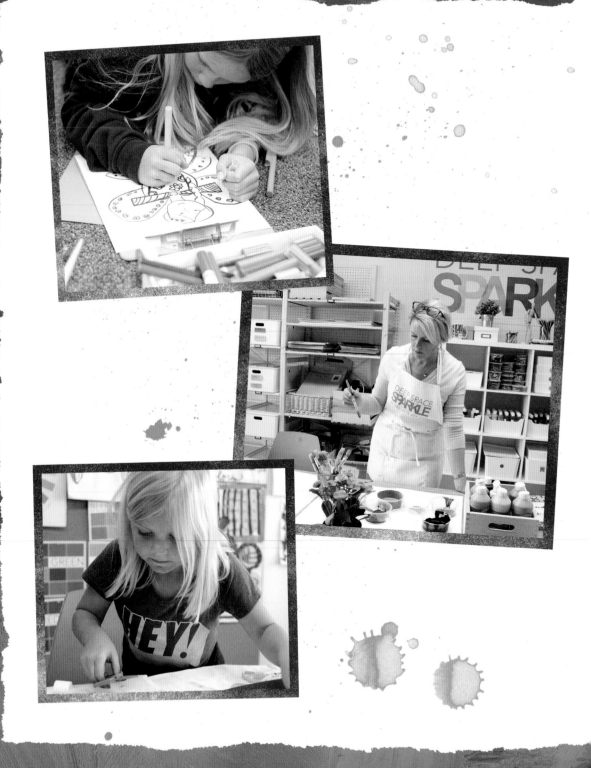

DRAW, PAINT, SPARKLE

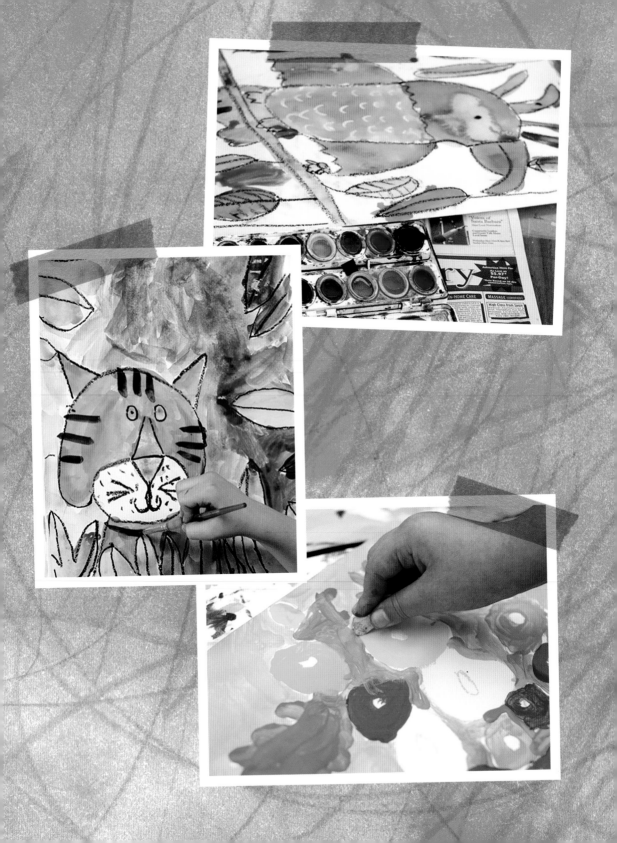

Draw, Paint, Sparkle

Creative Projects *from*
an Elementary Art Teacher

Patty Palmer

ROOST BOOKS
BOULDER
2018

Roost Books
An imprint of Shambhala Publications, Inc.
4720 Walnut Street
Boulder, Colorado 80301
roostbooks.com

© 2018 by *Patty Palmer*

All rights reserved. No part of this book may be reproduced in any form or by any means, electronic or mechanical, including photo-copying, recording, or by any information storage and retrieval system, without permission in writing from the publisher.

9 8 7 6 5 4 3 2 1

First Edition
Printed in the United States of America

∞ This edition is printed on acid-free paper that meets the American National Standards Institute Z39.48 Standard.
♻ Shambhala makes every effort to print on recycled paper. For more information please visit www.shambhala.com.

Distributed in the United States by Penguin Random House LLC and in Canada by Random House of Canada Ltd

Designed by *Cat Grishaver*

Library of Congress
Cataloging-in-Publication Data
Names: Palmer, Patty, author.
Title: Draw, paint, sparkle: creative projects from an elementary art teacher / Patty Palmer.
Description: First edition. | Boulder: Roost Books, 2018. | Includes bibliographical references.
Identifiers: LCCN 2017033077 | ISBN 9781611804713 (pbk.: alk. paper)
Subjects: LCSH: Art—Study and teaching (Elementary)—Activity programs.
Classification: LCC N350 .P265 2018 | DDC 700.71—dc23
LC record available at https://lccn.loc.gov/2017033077

*To my mother,
who showed me how
to live a creative life—
I am the artist I am
because of you.*

CONTENTS

INTRODUCTION

In my twelve years as an elementary school art teacher I learned a great deal about how children create art and what I found is this: when exposed to a variety of drawing mediums, subjects, and techniques, all kids will find an area of art that they are not only good at, but love.

When I left teaching, I dedicated myself to my website, *Deep Space Sparkle*, which is now a resource for elementary art teachers around the world. What began as a way to share pictures of my students' artwork with the school community now offers art training to teachers through workshops and art projects. The cornerstone of everything on the site is based on my interactions and experiences with children. I believe it helps to describe exactly what I've said—and not said—when explaining a lesson process to another adult. I show how children work through a project by photographing the process. The results go a long way in gauging how well a lesson will translate in a classroom or a home-study.

Through both of these roles—as a classroom teacher and as a guide for art teachers—I have a huge range of experience in teaching children. I have seen every type of learner. Some are highly creative and can work magic with a paintbrush. Some have never held a pair of scissors. With this range of skill, interest, and ability in mind, my favorite projects are those that allow kids to tap into their innate need to create, produce something that represents their point of view, and help develop their art-making skills.

I adore designing lessons that allow my students to experiment with different materials and techniques. While this work is a natural extension of all that I love, *you* may not feel the same way about drawing and painting. The goal of this book is to make the world of art-making accessible to kids—and you are an integral part of that process. If you're concerned about your lack of drawing ability or nervous about the mess that paint entails, don't worry. This book answers even the most basic art questions and proves that with a few tips and tricks, you too can teach art in your home.

ART-MAKING WITH CHILDREN

You might have a child who only needs basic art supplies and some free time to encourage their art interest. Or you may have to work a little harder to provide an art experience for your child. That's how it was for me when I became a mother. Once my three kids entered kindergarten, I was surprised at how little downtime they had during the day. Afternoons were a flourish of homework, sports, and playdates, while weekends were a compounded version of the week. After a while, I realized that if my children were going to create art, I needed to create the opportunity.

Today's children are exposed to an abundance of after-school activities and art may or may not be on that list. I found the best way to schedule art times was during playdates. Placing pastels, paper, and colored pencils on a table is a wonderful way to wind down after a busy school day and engage with friends. It allows children to create something with their hands and express themselves without worrying if it's right or done well. This was especially appealing to my daughter, who looked forward to a quiet activity. Not so much for my boys. For them, playdates were spent building forts, skateboarding, and playing with Legos. Art time for them was only attractive as one-on-one time with Mom.

But let's get real here. Most kids come home and head straight to a screen. Breaking kids from this habit isn't easy, but it can be done. The trick is to get them started with an alternative activity, like art. You may have to spend some time clearing the kitchen table and gathering some supplies, but once you know what to do, it gets easier. The witching hour before dinner can be chaotic, yet it is a perfect moment to make art. As you prepare dinner (or while you're waiting for the pizza to arrive), set out some paper and a few paints or markers, and draw with your kids. When you set out the paints, you may start to envision the masterpieces that you will hang on your wall—but be patient. Children may embrace your efforts or they may not. Don't lose heart. I'll share some of my art philosophies and practical tips that will help even the most reluctant artist.

You may be looking for ways to introduce an art project during your busy week. Perhaps you've been placed in charge of an after-school art class and need a few projects that will engage multiple age groups. Whatever your situation, I'm pleased that you found this book. I have projects that you can accomplish in a short time and cover the interest base for both boys and girls.

Sometimes it's not about the subject, but the technique. Let me reassure you: I've had 9-year-old boys really get into drawing ballerinas inspired by Degas all because of a cool chalk technique.

If you love children's art and are looking for projects that are easy, colorful, and fun to produce, I've got you covered. In fact, I'll provide lessons that you'll enjoy as much as your children will.

HOW TO USE THIS BOOK

Many people are attracted to an art project based on a picture they have seen in a book, on a website, or even through Pinterest. You can treat this book in the same way: Flip through to see what piques your interest. Gather the supplies, read the instructions, and follow the steps on your own (or at least part of them). Get a feel for the project before presenting it to your kids. Your discoveries might be as simple as figuring out the best place to start a drawing or what happens if you use a pencil instead of the suggested oil pastels. Some of the things you learn might seem small, but you'll be amazed at how important the details can be. This strategy works out the kinks, gives you confidence as the teacher, and allows you to see where potential frustrations might occur.

It's not necessary to do the projects in this book in order. Skip the ones that don't grab your interest. All of the projects presented here can be done in about one hour. Some require a little drying time between steps. I'll offer techniques, tips, and helpful guidelines with each project so you'll have an insider's guide to how each project worked with my group of kids. Just knowing the children's ages, what process we used, and how much time it took may help you when selecting projects for your group.

DRAWING HANDOUTS

I find it helpful to show children a very simplified drawing or image of a subject compared to the real thing when learning how to draw. Drawing an object like a flower by observation can be challenging for a 7-year-old. If you show a picture or a simple illustration, it's far easier for a child to see the shapes that make up the object. That's why I included simple drawing steps and drawing guides to help your child see the structure of the projects in this book. If you would like to download any of the PDF drawing guides, please visit drawpaintsparkle.com/downloads.

This book is your guide to teaching art. It will teach you popular art techniques so you can be the go-to art teacher in your own home.

PART

the ART ROOM

Chapter One
APPROACHING ART

As an art teacher, my goal is to help children explore art mediums and techniques in a fun way. My favorite projects show children how to draw simple subjects and then finish them with a choice of painting techniques. There are many ways to teach drawing to children. This book focuses on two styles of drawing instruction: directed drawing (drawing by following a series of steps) and observational drawing (drawing what you see).

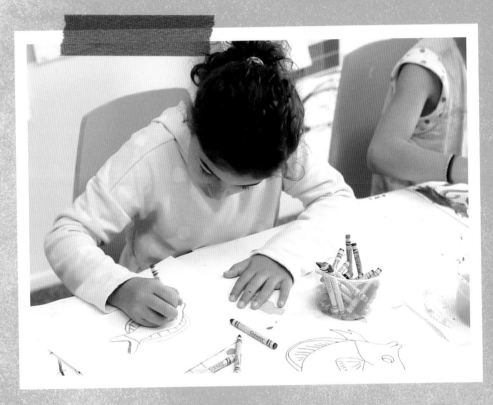

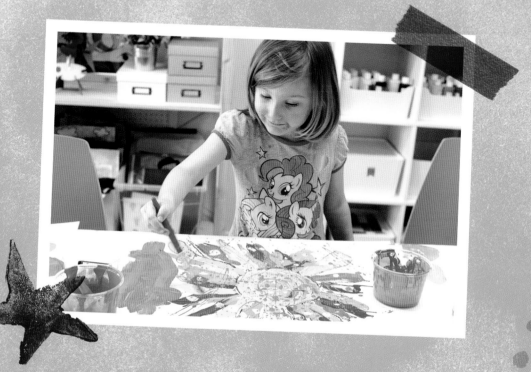

DIRECTED DRAWING

Drawing via a series of steps is called directed drawing or guided drawing. Many drawing projects in school are taught this way. In a classroom, directed drawing allows all children the opportunity to create a drawing that is perfect for their skill level. They do what they can and are often pleased with their efforts. This builds confidence and the interest to pursue more drawing activities. Something magical happens when a child who doesn't consider herself an artist draws something she considers artistic. Teach a 6-year-old how to draw a sea turtle and that may be all she does for two days! The confidence seed is planted and artistic roots develop.

If you are concerned that guided drawing preys on the innate creativity of children, you are not alone. Many teachers and parents discourage drawing from this type of step-by-step approach. If this is all an artist ever does, perhaps the statement is true. But it rarely happens that way. Children who are exposed to many styles of drawing benefit the most. Balance directed drawing by giving children time to sketch or doodle on their own—even if it's at a restaurant with a paper placemat and crayons. They thrive

under fine-art instruction as well as process art. Try not to judge the approach, but relax into the process and the experience. That's where the happiness lies.

If I haven't convinced you, consider this: Do you like to draw? If not, why? Perhaps you took an art class as a child and were asked to paint something on the paper. You watch the other kids mix the paints and begin their art. They seem to know what to do. You stare at the blank paper. Your forehead tightens. You wonder why your mom signed you up. This class is for artists, not you. You'd rather play soccer.

From that moment on, you claimed you were not an artist.

I get it. I hear it all the time. When I tell people that I'm an art teacher, their first response is, *Oh, I can't draw a stick figure.* Well, of course they can. But the negative story is deeply ingrained.

But what if this happens instead: You walk into an art studio. A bit nervous, but curious. Bottles of brightly colored paint line the shelves. Art hangs on the walls. The instructor welcomes you and gives you a piece of paper. She paints simple lines on a large sheet of paper. She paints fast and not very well at all. The instructor shares her process, one step at a time. She invites you to

follow along. Shapes and lines emerge from your paper. It feels good! The instructor ignored her messy lines, so you will, too. She squeezes more paint onto your palette, offers a tip for mixing paints into buttercup yellow. Who knew that adding white would make such a difference? You sink into the project and can't wait to come back again. You are proud of your art and you didn't even pick up a pencil.

Art doesn't have to be intimidating. It doesn't have to align with a philosophy or proven approach. The instruction or process just needs to be engaging enough to show kids that, with a few techniques, they can draw and paint most everything.

OBSERVATIONAL DRAWING

Drawing through observation is my favorite instructional technique. Once a child can identify lines and shapes (around 7 years old), they can easily identify how objects are composed of a series of shapes and lines.

Many drawing books are illustrated to show how to draw and connect shapes until a familiar subject emerges. Using pencils to lightly sketch boxy shapes and circles and then outlining the lines you like by pressing harder is a classic approach. I do the same, but without the use of pencils. For kids ages 5 to 8, we use a lot of light-colored crayons or oil pastels. And while you can't erase oil pastel lines, you can certainly paint over them. Which is what we do in many lessons.

I often show my students how I would approach a drawing, then allow them to approach the drawing in a way that suits them. Sometimes, just giving a child a starting point is enough to get them going. This is especially true with creating art at home or in a small group setting. Class sizes in a traditional classroom require a bit more structure to accommodate scheduling, standards, and various skill sets. Taking away the fear of marking on a blank paper is the biggest hurdle. Once kids get started, the possibilities are endless with this style of drawing. This is where you get to see a child's unique perspective. Many projects in this book use the observation technique.

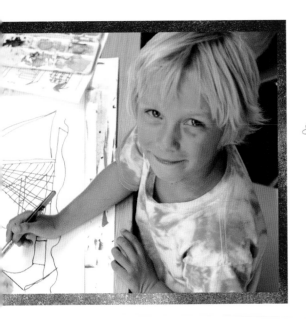

HOW TO HOST YOUR OWN ART SESSIONS

Teaching art in a classroom setting is often dictated by how much time you have to prep and how long you have to teach the lesson. Oftentimes a child just starts to get into the rhythm of art-making only to have to stop. Working with smaller groups at home with a flexible time schedule allows students to achieve a state of creative flow, which can result in wonderful explorations of art. Teaching in small groups can also be challenging. Children may feel less compelled to listen to Mom in the same way that they listen to their teacher. I find the best way to engage little artists at home is to create a space conducive to art-making.

Here are some things to try:

- Inviting more than a few kids to an informal art session with your child can become problematic. Setting out paints, paper, scissors, and glue can take some effort and some parents want to capitalize on their efforts by including a big group. In my experience, when an art date becomes group focused, the art activity has the potential to morph into a play opportunity. It becomes harder to maintain the focus for all children to work on their art. A small group of one to three children is ideal, but it also depends on the child. Start small and if the art date is working, add one or more children.

- When doing a drawing or painting project, try the project yourself to see what happens. Make a mental note if and when you struggled. You can share this experience with your kids and see if they struggle in the same area. Something about pushing past comfort zones creates a fun working atmosphere.

Simple directed drawing at home is a great way to build a child's confidence. I remember picking up an Ed Emberley drawing book when my son was about four. I showed him how to draw a few shapes. Together we turned the shapes into cars and trucks. This allowed for continued dialogue about the differences between excavators and diggers. He drew and talked. It was a great experience.

I often leave the coloring or painting part of the project free of instruction so that the children can exercise their own creative freedom during the latter part of the lesson. This way they get instruction plus the opportunity to make the piece their own.

Develop a relaxed approach with art supplies. A fun part about starting new art projects is loading up on supplies. Opening a fresh box of oil pastels is like opening up a box of possibilities. No broken bits. Paper covers intact. Heaven! This lasts such a short time because pastels are meant to be broken. So are crayons and chalk pastels. Paint trays will turn messy and liquid watercolors will get muddy. If this stresses you out, try to understand that it's hard to be an artist and keep supplies pristine.

It's not necessary to follow instructions to the letter. Have some fun with the projects and encourage kids to do the same. It's also okay not to finish a project and move on to another one. It's not quitting. It's exercising your creative rights!

If a child becomes frustrated, asking questions is the best way to ferret out what the child doesn't like about their art. I always begin by identifying something that stands out for me in their art. It may be an expressive line, an unusual use of color, or an area that is high in contrast. I usually avoid what I suspect they are worried about and let them state the problem.

Play music during art-making time. It helps establish a calm or inspiring mood. I like Jack Johnson's children's station on Pandora.

SETTING UP FOR ART

I love mixed-media projects involving layering pastel and paint, because children always end up with different variations of the project. The process tends to be messy, creative, and enthusiastic. On the other hand, painting with watercolors feels calmer. These projects are easy to prep; just pour water into containers, gather a few paint trays and paper towels, and you're ready. Both types of projects are fun to make but require different levels of prep. To keep the prep under control so you don't get overwhelmed, keep the following in mind:

- Designate one or two storage containers to hold smaller containers or packs of markers, pastels, pencils, paints, and papers. This is more efficient than having a dozen containers and boxes. Maintaining storage simplicity comes with the extra benefit of feeling like your home is still a home and not an art studio. When art time arrives, pulling out one container from a shelf or cupboard is easier than collecting supplies from all over the house.

- The kitchen is an obvious place to create art, but converting a table in the garage or even outside during the summer keeps the mess away from your main living areas. When my children were young, the only space in my house that was kept relatively tidy was my kitchen table. This is a great place to start.

- Strip your art table (aka the kitchen table) of anything not related to the project (placemats, iPads, magazines, books, saltshakers, etc.).

- Purchase large papers or tag boards for placemats. No need to personalize, just pull out the paint-splattered paper and place your art paper on top. The paint will dry nicely and won't stick later on. I store these papers out of sight on top of an armoire in my office. Another good place is an old dresser with large drawers.

- Encourage the children to share supplies whenever possible. A collaborative approach reduces the amount of paint and materials needed and makes prep a whole lot easier.

- Using Styrofoam egg cartons is a great paint delivery system. Be sure to place masking tape on the small holes that sometimes appear in the cartons. This will save you some mess.

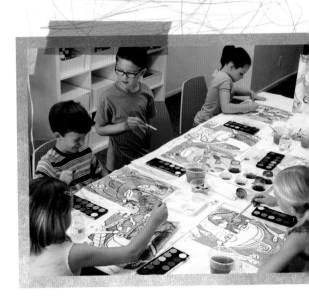

- Designate a special time for art-making. Maybe it's every Friday at 3:30 or Sunday mornings. Try for once a month and if all goes well, add an extra session. Don't worry if all you ever do is just get the paints set out. Children need time to develop a routine. I used the same technique when I introduced a new vegetable to the kids. A little bit every dinner until they got used to it.

- I approve of and love open-ended art projects, but if you have children of various ages, projects that don't have a certain flow encourage some children to lose interest faster than others. Keep a few art activities in mind or extra pieces of papers on hand to entertain the younger set while older kids work on their details. Coloring pages, books, and art puzzles are great choices.

HOSTING PRIVATE ART CLASSES

If you are leading a group of children for a formal art activity, perhaps as part of a homeschool group or private art class, you need to consider setting expectations. This is extremely important as other parents may expect that their child will create a piece of art. Here are my tips for teaching in a small studio or a home-based studio:

- Decide in advance the basic rules for your home: where children leave their jackets and schoolbags, where they go to the bathroom, what parts of the house they may enter, and when and where they may get a snack.

- Being an art teacher means helping children through the process of creating art. Ultimately, children are in charge of their creative expression, but sometimes they need permission to add a detail, color in a new way, or use an unorthodox color. It's a fine line between telling a child what to do and allowing them to express their art.

- I once had a teacher ask me what to do with a child who only wants to work in black and white. I sensed that a few battles had occurred over this. Here's the thing. Children often have a particular image in their mind—a way they see something—that is sometimes hard to change. So don't. Embrace the back and white and over time colors will emerge.

- Not all children will enter your studio or art space with the same activity level. Some kids are there because their parents want them to experience art. They may be squirmy and rush through the projects. If this happens to you, watch the child to see how long a perfect art session is for him. Perhaps he maxes out at 45 minutes. Perfect! Let the parents know that a 45-minute class and an earlier pick-up time is better for the child. You don't want to assume the role as a babysitter. The other children need your attention. And it will make a much better experience for the child.

- Create clear expectations to the parents on what the child will create in your class. If your class is strictly process art with variable outcomes, make it clear. If you are offering fine-art instruction, make it clear that you will teach art technique. Whatever style of art, whatever your approach, it's all fine. Just allow parents to decide if your style works for them. Children will do anything because they are far more open to opportunities. It's the parents you need to explain the philosophies to.

WORKING THROUGH MISTAKES

Occasionally kids struggle during art-making. Maybe they don't like their drawing or they dribbled paint onto their picture by mistake. They may want to tear up the paper or they may shut down. I've only had a few kids cry in my art class over the last years, but each time it happened, I felt horrible. Creating art should be a happy moment, but the truth is, it can bring out our greatest frustrations.

The best fix for this situation is to allow a child to express what he feels, but to move on with the project. Refocus your child by accepting the frustration but not judging it. This strategy works well in reestablishing an environment that is conducive to art-making. I like to

create a culture in which fixing mistakes is applauded. This comes naturally to me as I am on the opposite end of the perfectionism scale. I like risks and challenges and I don't worry. I acquired these skills through many hours of creating art during childhood. Developing fearlessness in young artists is the best gift you can give them. They will learn that satisfaction and happiness are on the other side of risk. This is why I limit the use of pencils in the art room. While pencils are an important tool for sketching, they can sometimes inhibit children from creating freely. I say this because using pencils means erasing mistakes. I prefer that mistakes be accepted in these early days of a young artist.

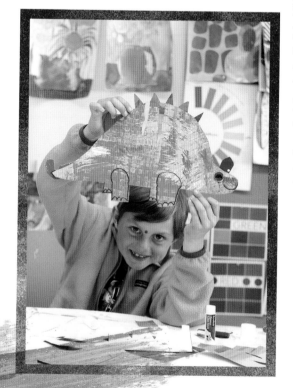

I make a big deal when one of my students turns a mistake into a part of their art. Sometimes we chuckle together and sometimes I sit back and watch how they manage the situation. Mistakes are a part of art so it's important to know how to embrace them as an adult and how to model this behavior for children. For my younger artists, we read Barney Saltzberg's *Beautiful Oops!* It's a delightful picture book that celebrates the wonderful things that can go wrong when making art.

When creating art with your child you may experience some pushback. By the time children are in fourth grade, they may want to create art on their own. If that's the case, embrace it. Be the provider of art supplies, give access to inspiration and tools, and step aside. If you want to join in the fun, do so to create your own art, not to be the teacher.

When you have a group of kids in your home for a formal art-making session, via a birthday party or a homeschool group, being the teacher or the guide is embraced at a different level. Read through the instructions for the projects and take the children through just a few basic steps. Print out the handouts available through the website and offer them to the kids. You'll be surprised at how well they do.

Chapter Two

ART
SUPPLIES

When creating art with kids, supplies matter. Knowing what supplies to buy and not buy is a game-changer. Believe me, having the right supplies can make a huge difference in how successful a child feels during and after his art-making session. Using inexpensive pan watercolors on copy paper doesn't create the same experience as using rich liquid watercolors on watercolor paper. So stay with me. I'll share what works great with kids. And the supplies won't break the bank.

stores occasionally carry sulphite paper (you'll have to ask) and many sketchbooks offer lignin-free (or acid-free) paper. As long as the paper inside a sketchbook is smooth (not furry) and heavier than copy paper then it should be fine for art projects.

tip

Sometimes sulphite paper is called construction paper, but don't be misled. It's not the construction paper that you would find in the kid's craft aisles. That type of paper is not meant for art projects that involve painting or drawing.

SULFITE DRAWING PAPER

When I first began teaching, my biggest question concerned paper. Art supply lists included paper, but what type of paper? Would regular copy paper work? What about card stock? What about those large sketchbooks? Basically, my question was: Is there a special art paper that only art teachers knew about? The answer was yes. It's called sulphite paper.

It has a fancy name, but it's basically a smooth white paper that has the lignin removed. Lignin is the culprit that turns newspaper brown. Removing it results in an art paper that is perfect for most mediums including tempera paint, chalk, and oil pastel.

Sulphite paper comes in various weights, but most stores carry the 76-lb weight. No doubt your child uses this paper in school. It's a popular art teacher's choice. It comes in packages of 50 sheets in a variety of sizes. I use the 12" x 18" size most often. Office supplies

WATERCOLOR PAPER

In order to do the lovely watercolor techniques in this book, you'll need a paper that can handle this liquid medium. I like 90-lb school-grade quality. If you buy a very expensive watercolor paper (cold-pressed 130-lb), the projects won't turn out as well. I know it's counterintuitive, but a toothy watercolor paper is hard for children to draw on. Markers don't work well on fuzzy paper. By all means, stick with the school-grade and least expensive watercolor paper you can find.

tip

I use watercolor paper strictly for watercolor paints. It's best to use tempera paints on regular—and less expensive—sulphite paper.

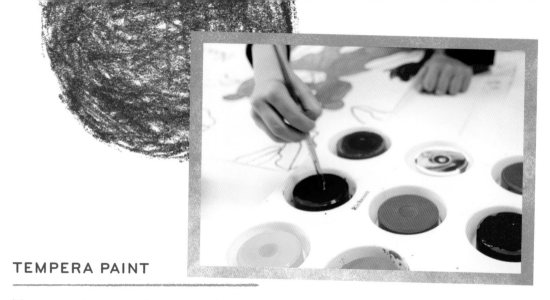

TEMPERA PAINT

Tempera paint comes in two popular forms: liquid and cake. They are both staples in my art room. Liquid tempera is a thick, washable paint that comes in many colors. The paint mixes beautifully and it cleans up well. But not all tempera paint is the same quality. When buying tempera paint for the first time, buy a small bottle and do the stroke test. Dip a paintbrush into the paint and brush the color onto white sulphite paper. If you can easily see the brush strokes, the paint is not good quality. You want the paint to be opaque and vibrant. My two favorite brands are Faber-Castell (intense color and finish) and Crayola Premium paints.

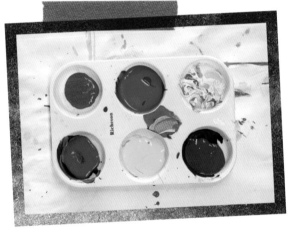

Tempera paint typically dries to a matte finish and can crack a bit. This is completely fine for student art, but if you want a shinier finish, then acrylic paint is a better choice for you. Beware though. Some acrylics are hard to use. In my project Painted Parrots (page 127), I share strategies for working with acrylic paints.

Cake tempera paints look like little hockey pucks or oversized watercolor cakes. They come in trays, which makes them very easy to place on a table for immediate use. No pouring, mixing, or cleaning up. The only drawbacks are that the colors aren't as intense, the paint doesn't mix as well as liquid tempera, and the paint dries chalky.

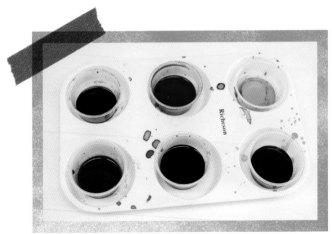

WATERCOLOR PAINT

I use two types of watercolor paint in my art room: liquid watercolors and pan watercolors. School-grade watercolors are generally pretty good and it's an affordable way to start, as most tray sets are less than $3.

What I look for in watercolor paints is a good saturation of color without being too sticky. Tray watercolors are great for experimenting with mixing colors. As children get older, they want more control over their colors. The tray covers serve as a paint-mixing palette so children can create a puddle of color and then use that color to apply to their artwork.

Liquid watercolor paints are easily my favorite. They are condensed colors that come in small bottles and are very similar looking to food coloring. The idea is to mix the concentrate with a bit of water to create a ready-to-paint color. These are fantastic for small children. All they do is dip a fat brush into a small container and paint the color on paper. No swirling or mixing necessary. Because the colors are so vibrant, the artwork is stunning and satisfying. Once you start using liquid watercolors, it's hard to go back to the cake kind.

To make storage easy, pour a few tablespoons of liquid color concentrate into a baby food jar or small plastic salsa container and mix with a small amount of water. I like a 4:1 ratio of color to water.

PAINTBRUSHES

Be picky about your brushes. This doesn't mean buying the most expensive sable-hair watercolor brush, but the right brush really helps children succeed with certain techniques. Small, medium, and large round brushes are all great to have on hand. The small brush is great for outlining, the medium brush is good for all-purpose painting, and the larger brush is great for laying down bigger areas of

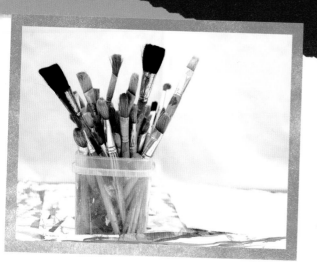

color. I like all-purpose brushes to use with both tempera and watercolor paints.

Buy a few fat, plastic-handled kid brushes. These are brushes with a fat handle and bristly ends that look like they are made for little kids—which they are. They are great for painting big areas of color with thick tempera paint for making painted paper. An alternative to this brush is a large flat-end brush. My favorite brand is Royal Langnickel Big Kid's Brushes. They feature a plastic handle and a grip. We use them in all of the projects for this book. Faber-Castell also has a great kid pack of brushes that are very similar to Royal Langnickel brushes.

PALETTES

Now that you have paper and brushes, you'll need something to hold the paint. I love six-well, plastic muffin-style palettes. I use these for everything from liquid tempera paint to plastic salsa cups filled with liquid watercolors. It's hard to save liquid watercolors if you squirt them directly into the muffin-palette and if you do use salsa cups on their own, they tend to fall over and spill. The muffin-palette really saves the day.

I buy packs of clear plastic pint-sized containers and lids from our local restaurant supply store. I use these all the time. I especially love them for mixing tempera paint colors. Children dip their brushes into the premixed paint and create. Pop on the lid and save paint for another day.

tip

If you buy Crayola or Prang watercolor tray sets, they often come with a brush. Sometimes the brush is nice and other times it's not. If the bristles feel soft, keep it. But if the bristles are black and wiry, use the brush for applying white school glue onto paper.

tip

Styrofoam or paper plates are great when you are teaching a color mixing lesson, as each child needs to control their own paint mixing. I prefer Styrofoam plates as I can rinse them off and use again, plus the paint doesn't soak into the plate, as it would do if using paper.

OIL PASTELS

Oil pastels are the most important art product I used in my art room. They deliver a lovely waxy color without much effort from the child. You can purchase inexpensive oil pastels and you can purchase expensive brands. If you are budget conscious, take comfort in knowing I only buy the lowest-priced oil pastels available. They work well for me. Spending more on some products is beneficial; overspending on oil pastels is not. Here's the secret: the oil pastels I use are not expensive because they don't have high oil content. Without the oil, the pastel will smudge less. This is a great benefit for kids.

If you are hesitant about using pastels, here's why I love them:

- Black oil pastels make a great drawing tool. You might think that drawing with an oil pastel, let alone a black oil pastel, is downright frightening. Let me assure you that once you are comfortable with this medium, the children will draw big, beautiful, and bold shapes that beg to be painted. It's also a wonderful finishing medium, which gives that extra pop to many art projects.

- Oil pastels on watercolor paper make an excellent barrier for the watercolor paint. When you don't want the paint colors bleeding together, drawing with oil pastels instead of marker or pencil is like building a wall so the paint doesn't blend together.

- Oil pastels applied over tempera paint bring the artwork to life. I use this technique a lot because children are mostly messy painters. Children find it hard staying within the lines (I do, too!) so after the paint dries, using the oil pastel to bring attention back to the lines really makes a difference. Using other colored pastels works equally well, adding patterns to a painted fish or details in a painted tree.

If the oil pastels smudge while the children are working, try not to over-react. The children will take visual clues from you and will see how you respond to their smudge concern. Assure the child that all smudges will be covered in paint.

CHALK PASTELS

Although chalk can kick up a lot of dust—and for that reason some adults may prefer not to use it—it can also be a wonderful medium for many art projects. In this book, we use chalk pastel as an embellishment over paint so the dust factor is reduced.

Chalk pastels deliver a lovely color to paper and it's like painting with your fingers. Black chalk, like black watercolor paint, can be a harsh color to work with. I remove the black chalk pastels from the trays and place them in a larger plastic container. When I need to use black chalk, I have it sorted already. The black chalk is helpful when you are doing a shading lesson over tempera paint.

Every once in a while, a child will have an aversion to the feel of the chalk. I'm sympathetic as I really dislike the dusty feeling, too. Offer solutions like placing a damp towel near the child's workspace, or have some baby wipes handy. Oftentimes, a child will work through the discomfort if they know that they can wipe their hands when they reach the tipping point.

Hairspray makes a great, inexpensive fixative. However, the spray tends to affect the artwork. Spraying is always a bit nerve-racking, as you never know what's going to happen. My advice is to use a brand with the finest spray. For me, Final Net hairspray is the best.

The thing to remember about art supplies is that not all brands perform the same way. If you intend on doing art frequently with your kids, it helps to understand what mediums are supposed to do. Tempera paint is meant to be opaque. Watercolor paint is meant to be transparent. Oil pastels are meant to be slick and smooth. When you find a brand that works for you—no matter what the price—stick with it. And by all means, test a medium out before embarking on a lesson with your kids. Not only is it fun but it also gives you an idea of what to expect.

Make sure to take a look at the resources section for my favorite art supplies and where to find them. Also, check out my website, www.deep spacesparkle.com, to see videos of how to use art supplies and lessons that work well with each medium.

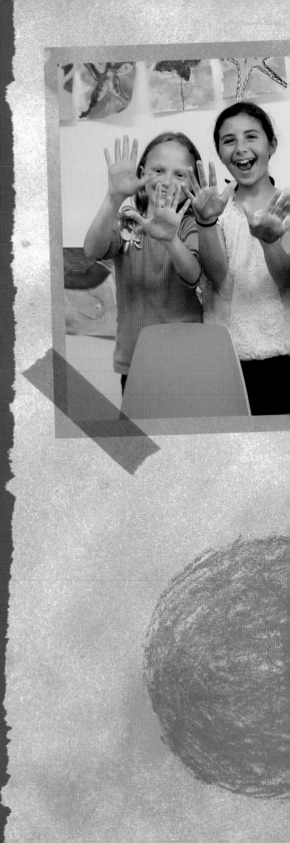

Chapter Three

ART
SHOWS

An overlooked part of art-making is taking the time to reflect on or appreciate the effort that went into the creative process. As adults we are quick to offer praise and excitement. Is this wrong?
Not in my experience.
I don't know a child who doesn't appreciate a compliment. And learning to accept compliments is part of our social norm.

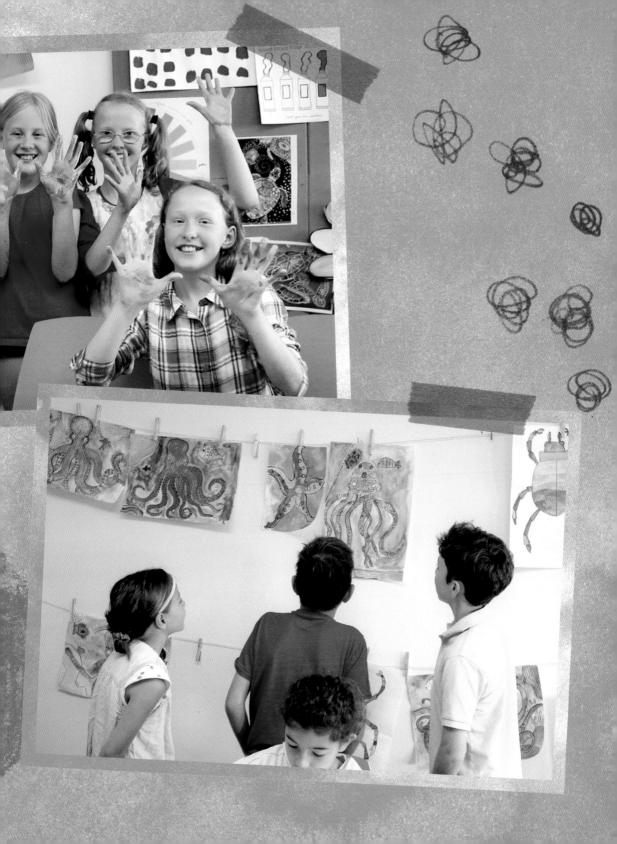

Although, when it comes to art, you may have heard that you should avoid comments that imply preference. I get it. We want children to express their ideas through art without imposing judgment—good or bad. Asking what the drawing is implies that it wasn't drawn well enough to inform the viewer of the intention. So what do you say?

First of all, don't worry. Genuine attention and interest can never be misinterpreted. But take the old adage of *show, not tell* when talking to your child about his art experience. The simple act of taping the artwork to the fridge, pinning it to a wall, or propping it up next to the kitchen table indicates that you enjoy the art. A child may dismiss your gesture but the meaning behind the action will resonate with most kids. If a child balks, take it down. Tell her that you enjoy the art and invite her to select a piece for display if she likes.

This simple gesture is the starting point for a child connecting his efforts with emotions. How an admirer feels about the art compared to how a child feels about their art is often very different.

When I was a girl, I spent hours in the corner of my room drawing. I amassed hundreds, if not thousands, of sketches and drawings. I had a series of character drawings that told a story. I kept the story inside my head and the drawings hidden away inside school binders. I wouldn't share them with anyone. Occasionally my sister would look through my drawings. My parents certainly saw glimpses of them. But because the drawings were a direct reflection of the dreamworld I lived in, exposing them to strangers was unthinkable.

I tell you this because not every child is willing to share their art, especially if the art is based on sketches and drawings from their imagination. If you meet this type of resistance, the best approach is to sit with a child and allow them to show you what they feel is safe. *Safe* may be a strange word when referring to drawings, so let me reassure you that I don't mean ignoring any disturbing subject matter. Safe in this case means allowing a child to create art in a space in your home without hovering or constant queries and remarks. Just allow them to sit and draw, and if they are inclined, let them show you their art on their own terms.

The projects in this book are not meant to tap into the same emotional well. They are meant to explore drawing and painting techniques and to express oneself through a fine-art project. For

nonartists and even parents, these projects are designed to build confidence, create an enjoyable experience, and show children that they are all artists. Part of the fun while teaching art in school and through small group workshops is sharing the art with each other and the parents.

You can promote conversations while the kids are working on their art. Questions or statements can be simple: I love that you chose purple and Amanda chose yellow. What made you decide to choose those colors? Or, you can be specific about the craft: Do you prefer working with watercolor paints or oil pastels? Often what will happen is the other kids will listen and share their thoughts about their selection process. This often leads to appreciation for each other's work. So you see, art appreciation doesn't have to be formalized. It can occur quite organically.

HOW TO HOST AN INFORMAL ART SHOW

Deep Space Sparkle began as a blog designed to share the art process with my students' parents. And while a few parents enjoyed viewing images on a blog, nothing came close to the energy and excitement of viewing a collection of art projects in an art show.

Organizing an art show can be as simple as hanging art on a length of twine across your living room wall. Or you can get a bit fancier by matting artwork and presenting it in a formal room. While the size and scope of your art show may be different, selecting the artwork to be featured can be hard for many teachers and parents. Many public school art teachers I know dedicate a few classes to the process of selecting art for an art show. Allowing a child to look through his body of work through a portfolio review is a great way to share your appreciation of his efforts. You can do the same at home. When determining what piece is the child's favorite, here are some simple criteria to follow:

- Is the work completed?
- Is the child proud of his efforts?
- Does the art represent his best work?

This simple selection process allows for the selection of completed work that the child is proud of. This eliminates rough sketches and art that didn't represent much thought or effort.

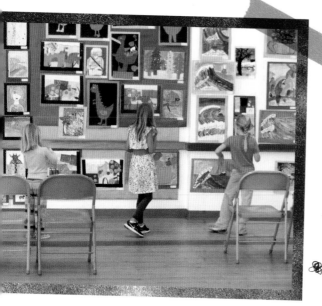

COLLECTING AND
DISPLAYING ARTWORK

If you have been teaching art around a kitchen table, hosting an informal group, or just allowing your child to create art, these tips will help prepare for an art show by creating a body of work for each artist:

- Create a paper portfolio for each child. This can be as simple as a folded piece of 18" x 24" paper. Allow the child to decorate his portfolio with paint, stickers, or drawings.

- Allow the child to decide what to save in the portfolio.

- Write the following information on a sticky note or in pencil on the back of the artwork: child's name, age, location, and their thoughts about the piece (title, what they liked, didn't like, favorite part, quote overheard during the art-making, etc).

- Mount artwork in advance. Use rubber cement to adhere artwork to a colored matte board or colored paper. Rubber cement is good because it allows you to remove the artwork from the backing without disturbing the integrity of the art.

- Use clothespins and thick craft twine to display artwork on a wall or in a hallway. This is what I did in my studio. After each session, we hung the artwork on the clothesline to dry, but it also served as a way to observe, reflect, and admire the art of a fellow artist. This was the best part of many lessons. The kids loved seeing what everyone created.

- Simple craft easels or tabletop plate stands from the craft store can make tabletop viewing easy. Or if you don't want to purchase these, you can make a good resting place for mounted artwork by using a cardboard box wrapped in colored paper.

Many children are eager to help with art show preparations. Ask children to help make invitations to send to neighbors, teachers, parents, etc. If you teach in a school or have a studio, engaging kids in this process is another way to reinforce the importance of art.

As the school year winds down in late spring, this is the perfect time to host an art show. This is the time when students are eager to fulfill community-service-hour obligations and teachers allow the students the time to do so. Standardized test requirements are also completed, which affords teachers more time to spend on these types of activities.

Ask children to help make a welcome sign for the art show using tempera paints and lengths of craft paper. Not every child can participate in this activity so have other opportunities as well. Consider adding a table or spot on the floor with paper and crayons available for younger children to doodle, a large sheet of paper hung on the wall for older children to add their mark, or a small area for making crafts or painting small papers.

Whatever you do, enjoy the planning process just as you would enjoy creating the art itself. It's all meant to celebrate the artistic efforts of children. For more help planning an art show, visit www.deepspacesparkle.com/art-show-guidebook/.

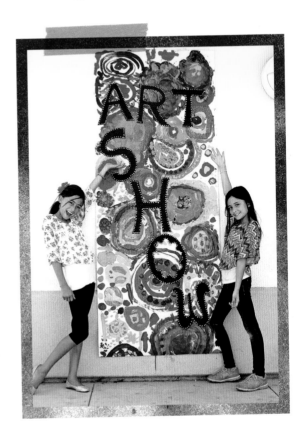

PART

the ART CLASS

Chapter Four

BEGINNINGS

Just like art teachers start the school year with simple art projects, this book offers you a few simple projects that require basic supplies and offer flexible instructions so that all children can be successful.

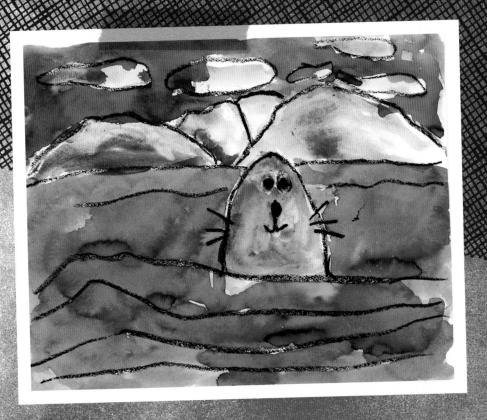

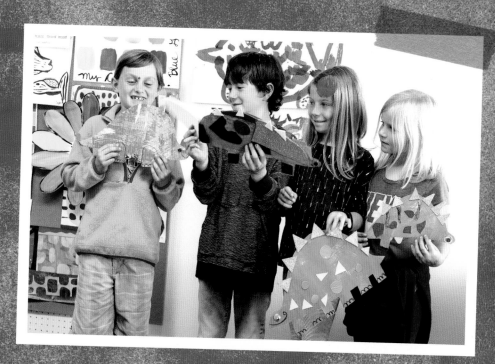

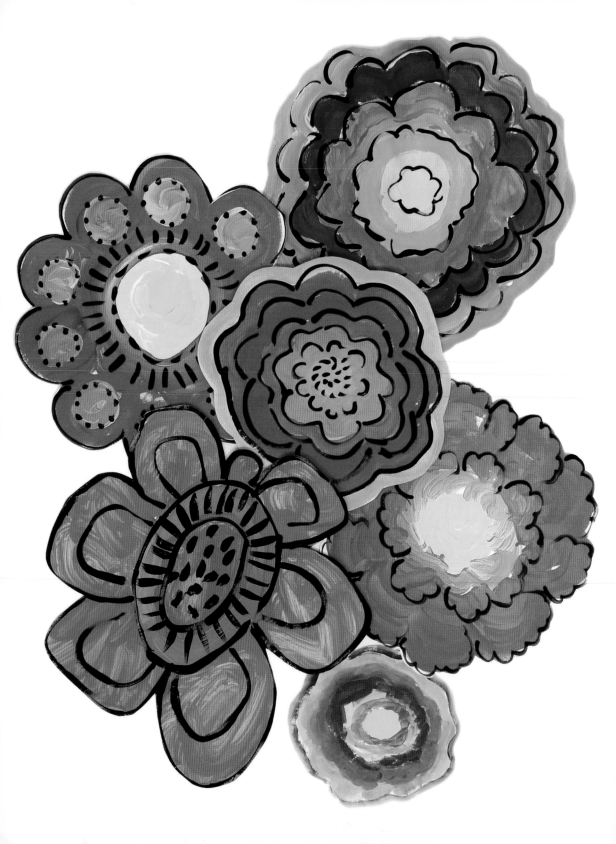

BIG & BOLD PAINTED FLOWERS

If you are new to drawing and painting, sometimes it is easiest to start with a familiar subject that allows you to paint a simple shape with beautiful colors. These big and bold flowers are just the thing.

THE SETUP

Cut a piece of 12" x 18" drawing paper down to 12" x 12". The square shape provides a neat parameter for a round flower. Use liquid tempera paint or any thick opaque paint. This is a good time to use the small bottles of acrylic paint found in craft stores, as they are inexpensive and come in many colors.

Reduce the amount of color choices to eliminate the risk of creating muddled paint colors. My advice is to set three colors at the table, plus white and black. Good color families are red, yellow, and bright pink; or dark blue, light blue, and green. The combination of the three colors plus the white allows for a great variety of color mixing opportunities, while the black paint adds a sharp focus to the final flower painting.

what you'll need

- 1 sheet of 12" x 18" white drawing paper per child
- Liquid tempera paint or acrylic craft paint. Select one color option per flower: red, yellow, and bright pink; or dark blue, light blue, and green
- White liquid tempera or acrylic craft paint for mixing tints
- Black liquid tempera for outlining
- Medium-large brush
- Black oil pastel for drawing
- Round plastic lid to help small children trace the flower center

what you'll learn

- How to make a tint with white paint
- How to draw a flower
- How to paint without cleaning your brush

THE PROCESS

Older children can dive straight into painting the flowers, but for the under-7 set, it's helpful to have them draw the flower first. Start by drawing a circle or tracing a round container top and then add big petals all around the circle.

tip

After drawing the circle, make small markings equal distance from each other. These markings will be the start of each petal. This helps small children make equal-sized petals. From there, connect the markings together with a looped line to form the petal.

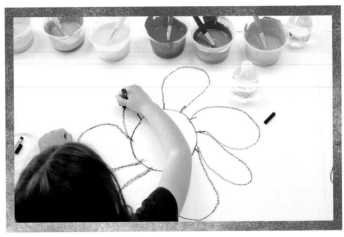

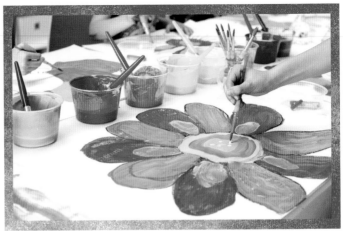

Using a large round-tip brush, scoop up the lightest color of paint (yellow). Start in the center of the paper and paint a circle shape. Without cleaning the brush in water, dip the brush in the medium color paint (red). Paint a petal shape. The petals can be thick or thin, long or short. Repeat painting more petals in a radial design.

Once the flower shape and petals are complete, set the painting aside to dry until the paint is sticky but not wet. Outline the petals, center, and add any other details with a small paintbrush dipped in the black paint. When completely dry, cut out the flower and display in clusters.

What is a tint? A tint is any color mixed with white. To create a tint, scoop up a small amount of white paint and immediately scoop up another color. Paint the two colors onto the paper. See how the paints blend together? This is called a tint.

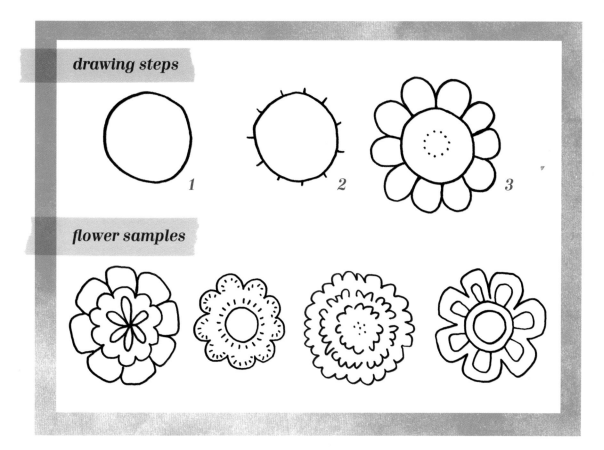

drawing steps

1

2

3

flower samples

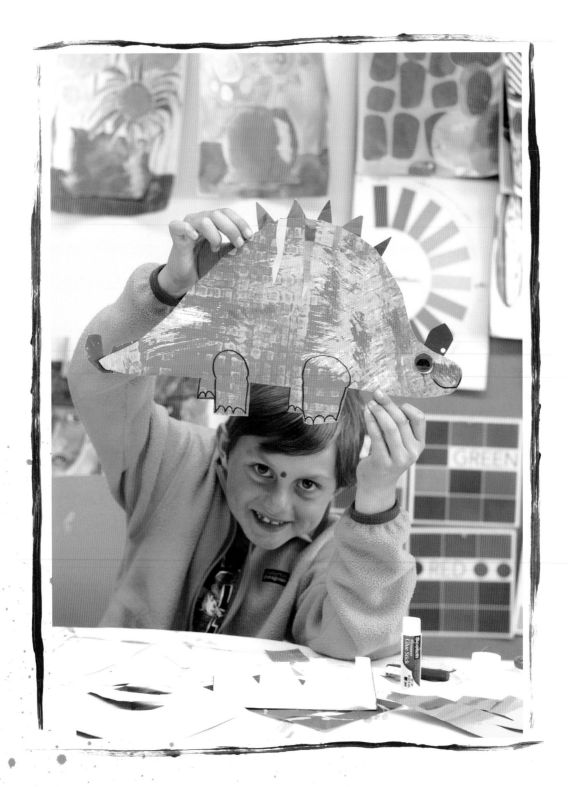

PAINTED PAPER DINOSAURS

Painted paper originated from Eric Carle's picture book illustrations. Carle splattered, smeared, and brushed paint over tissue paper to create textured paper to use in his picture book collages. This project uses painted paper and simple supplies like crayons, scissors, and a glue stick to create colorful dinosaurs. I use a simple guided drawing to draw the head, body, tail, and legs of the dinosaur. The children cut out the large silhouette and then use paper scraps to add details.

painted paper

The process of making painted paper is as much fun as creating the collages. Art teachers either embrace the inevitable mess or avoid it. I loved showing children how to make painted paper early in the year so that we'd have stacks of beautiful papers to create with all year long.

what you'll need

- Sheets of sulfite paper
- Liquid tempera paint in 3 or 4 colors
- Medium-large brush
- Plastic texture tools (such as a fork, scraper, or plastic gift card)

what you'll learn

- How to use big arm movements to paint sheets of paper
- How to create texture in the style of Eric Carle
- How to create a collage-style composition

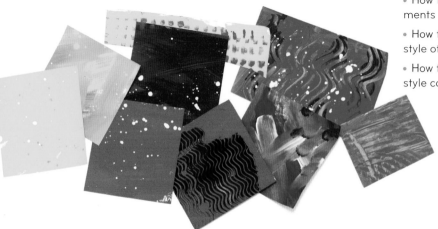

THE SETUP

To get ready for this quick and engaging project, protect your table surface with large paper placemats or newspapers. Place various colors of liquid tempera paint into muffin-style palettes or premix larger quantities and place in pint-sized plastic containers with lids.

tip

Set out tubs of paint colors that when blended together will not turn into a muddy color. In the art room, I placed three or four "friendly" colors of paint at each table group. Good examples are pink, yellow, red, and white; or blue, green, purple, and black.

It's much easier to place a brush or two into each container of paint. But if you are using a muffin-style palette, let each child use their own brush. They will need to clean the brush after introducing each new color.

Instead of tissue paper, I recommend using sulphite paper, as a lot of paint is used in the process. The heavier paper will support the weight of the thick tempera paint. Having a placemat underneath the artwork encourages this group to paint off the edge of the paper. Set the paper aside for a day to dry.

THE PROCESS

Dip your brush into one color of paint and paint over the entire surface of paper. Paint off the edge of the paper onto your placemat.

tip

Children will likely focus their paint strokes in the center of the paper. To avoid a big, soggy hole, show your child how to use long, sweeping arm movements to spread the paint over the entire paper.

Dip your brush into another color and paint swirls, lines, stripes, or dots. Create patterns or an all-over design. Clean your brush and choose another color of paint. Add more patterns. This time, think about painting in the opposite direction.

Pick up a plastic texture tool like a fork or scraper and drag it over the wet paint. What happens? Try dragging from one side of the paper to the other.

Splattering paint over the surface is a fun last step. Clean your brush in water and dip it into a light color of paint. I like using yellow or white. Dribble paint over the entire surface or in a few select spots. Try tapping the brush against your finger to control where the splatters go. Set the painted paper aside to dry.

Children really enjoy getting messy and exploring what paint can do. Aim to create two to four papers per child. When the paper dries, you can use it for various projects, including a few in this book.

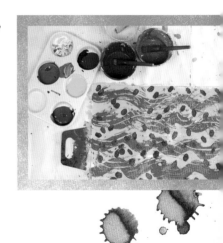

painted paper dinosaurs

Drawing dinosaurs is a favorite art activity for kids. This project focuses on drawing a simple dinosaur directly onto the back of a piece of painted paper. Children use paper scraps to add spikes, spots, plates, and patterns.

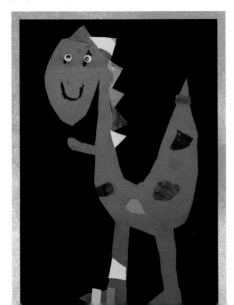

what you'll need

- Several 12" x 18" sheets of painted paper
- Black oil pastel for drawing
- Scissors
- White school glue
- Black marker for drawing details

what you'll learn

- How to create a dinosaur using paper shapes
- How to draw two dinosaurs
- How to share art materials

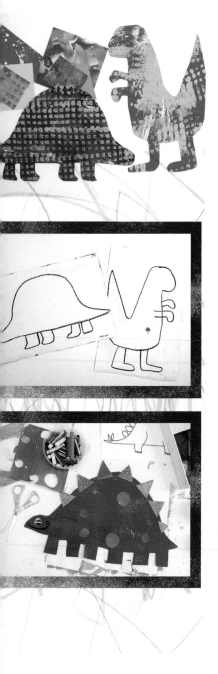

THE SETUP

Cut a few large sheets of painted paper into 6" x 6" squares so children will have a few colorful options to choose from when decorating their dinosaurs. I like to place the different colors of painted paper in a small tray. If you have children under the age of 5, using glue bottles can be a struggle. Instead, squeeze ¼ cup of white glue into a small plastic container, mix in a tablespoon of water, and use an old brush to apply the glue.

THE PROCESS

Select a piece of painted paper to use as the dinosaur body. Turn the paper over and, using a black oil pastel or crayon, direct your child in drawing a dinosaur (see "How to Draw a Stegosaurus" and "How to Draw a T-Rex"). Encourage kids to draw as large as they can so they can have fun adding lots of details to their dinosaur.

If you make a line you don't like, cross it out and try again. You won't see these lines on the finished dinosaur. Once you have drawn your dinosaur, cut along the lines you like. Turn your paper over to see your dinosaur.

Start decorating your dinosaur with brightly colored paper. Children can share the painted paper scraps that resulted from cutting out the bodies or you can dig into your own collection of paper scraps to add the details. Add spikes, claws, eyeballs, teeth, and horns in any way you like—glue cut paper to your dinosaur or draw your features with the black marker. Children like to glue pointy triangles or spikes to the backs, polka dots inside the body, claws and spikes on the tail. The sky is the limit. You can even add a wiggly eye.

If you like, paste the dinosaur onto any color of paper. I used black paper so that the colors in the dinosaur will pop.

stegosaurus

To draw the stegosaurus, start with a backwards letter *C* near the bottom corner of the horizontal piece of paper. This is the head. This dinosaur has a big back that turns into his tail. Draw the big hump for the back first and extend into the straight line for the tail. For the bottom of the tail and body, draw a straight line back toward the head. Now all you have to do is add two rectangles for legs. Cut the dinosaur out then turn the paper over to the painted paper side and draw a curved line up from the legs to inside the body. This line makes the legs look strong and powerful.

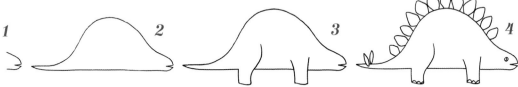

T-Rex

Start with the T-Rex's head by drawing a sideways letter *U* in the upper right-hand corner of the paper with a black oil pastel or crayon. To draw the body, place the oil pastel on the "chin" and draw a straight line down the side of the paper. Before the line hits the bottom of the page, draw a curve so it looks like the letter *J*. This is the belly. Continue this line all the way up the other side of the paper to form the tail. The tail can go up as high as you wish. Go back to the head and place the oil pastel on the top part of the letter *U*. Draw the back of the head and scoop around to form the top part of the body and the tail.

It's time to add T-Rex arms, which are quite small compared to his legs. Place the oil pastel inside the body just below the T-Rex head and draw two slightly curvy lines that go over the body line and extend to the side of the paper. Add claws. Draw another arm behind the body. Draw the big hind legs by placing your oil pastel inside the back end of the body. Draw a curved line for the top of the thigh. Draw another slightly curved line for the bottom part of the thigh. It looks like a man's leg! Then add the bottom leg or the calf. Remember that the hind legs are big. Add the feet with three claws.

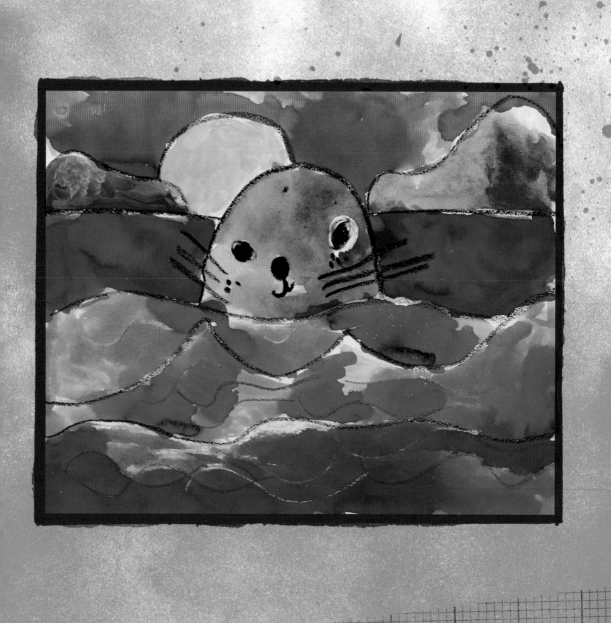

WATERCOLOR SEAL

Learning how to draw a seascape is a fundamental part of elementary art. Introducing how the horizon line separates the sky from the water is important recognition of how seascapes are arranged. Add a seal and this project is as easy and cute as you can get!

THE SETUP

My favorite projects to do with children involve liquid watercolor paints. I discovered them midway through my teaching career. The difference between tray watercolors and concentrated liquid watercolors is best described through the experience it creates for children. Dipping a paintbrush into a pot of liquid color and then applying the color to watercolor paper is like magic. The colors are as intense as you make them. Add water to the concentrated liquid and the colors become lighter. I find it best to use very light colors like yellow and orange full strength and add water to darker colors like red and blue. This is the paint of choice for our seal seascape painting.

THE PROCESS

To draw the seal, start by drawing two large dots about a hand's distance away from each other. Add a round nose and a small smile. Over the face, draw a hump for the head. Every child will create a distinct seal personality just by drawing these few lines and shapes. To complete the seal, add a few freckles and whiskers.

what you'll need

- 1 sheet of 12" x 18" white watercolor paper per child
- Black oil pastel
- White oil pastel
- Liquid watercolor paints
- Medium round brush

what you'll learn

- How to paint using a wax resist
- How to paint ocean colors
- How to draw a seascape using a horizon line

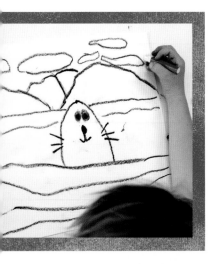

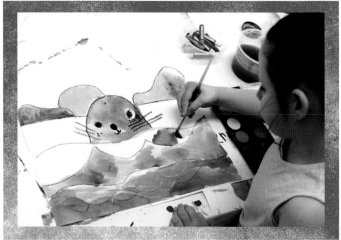

What is a *horizon line*? It is a visual line that separates the sky from the earth or water. It is the height of the viewer's eyes when looking into the distance.

This lesson is great for all age groups because even the youngest child can draw a seal. And the ocean is just as easy. Start with the horizon line. Place a black oil pastel on one side of the paper, draw a line toward the seal, hop over the seal, and continue to the other side. The line should be as straight as possible.

Place an oil pastel on the side of the paper near the bottom of the seal and draw a rolling line just under the seal's head and to the other edge of the paper. Next, draw a series of waves below the seal. They can be pointed or curved. The child can add anything they like above the horizon line. Perhaps a setting sun, a wharf, or even a boat.

Set out four to six colors of liquid watercolors. Place the colors in baby food jars or small plastic condiment cups. If you don't have black or brown liquid watercolors for the seal, you can do one of two things: mix red and green together or use tray water-color paints. We used a mixture of red and green liquid watercolors to achieve a reddish-brown.

Switch to blue and green paint for the ocean. Paint the sky a color that is slightly different than the ocean. This can be tricky so offer pink and orange watercolor options for brilliant sunsets.

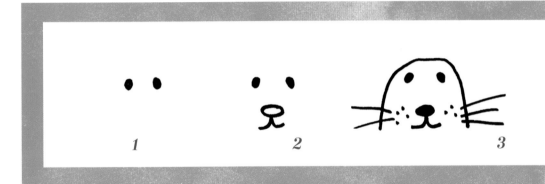

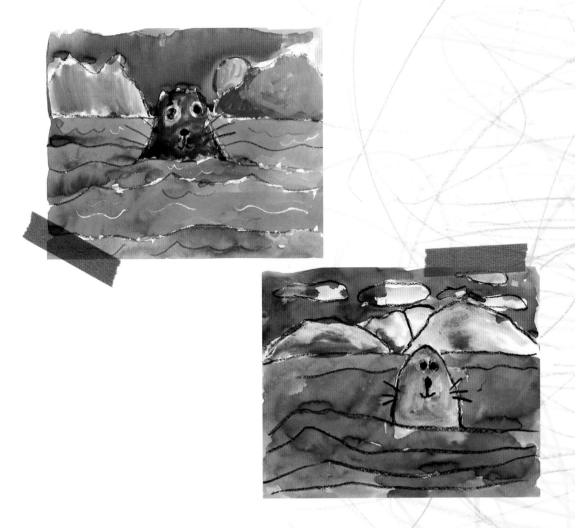

INSPIRED BY THE MASTERS

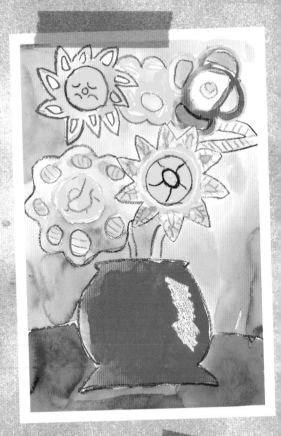

I learned more about the masters from teaching children than I did studying art in college. Using children's picture books to introduce the artist (see the resources section for a list of my favorites) helped translate information that kids might consider boring in a colorful, interesting way.

One question that children would ask over and over was, why is this artist famous? It was my favorite question. An artist usually became famous because they created art that was considered different. For many artists, it took a lifetime for people to appreciate their work. It didn't always happen this way, but one thing is true: the artist believed in their art and practiced every day.

I can't think of a better lesson for an aspiring artist than to honor what makes them different and to keep creating.

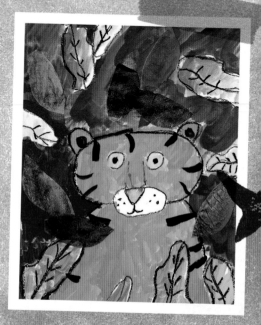

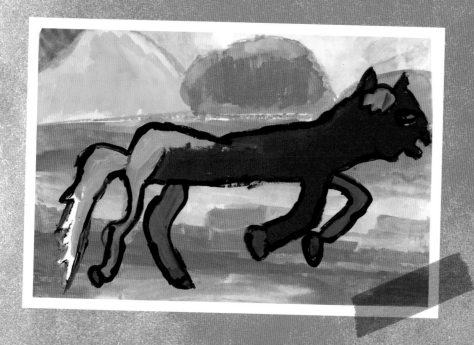

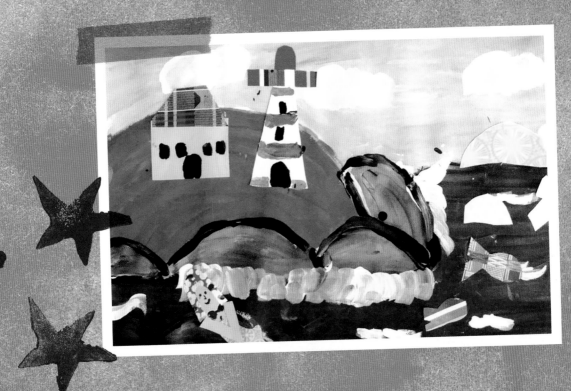

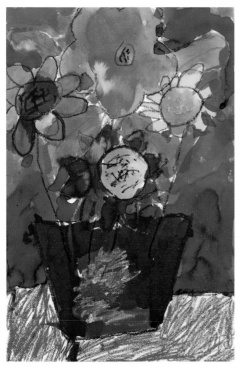
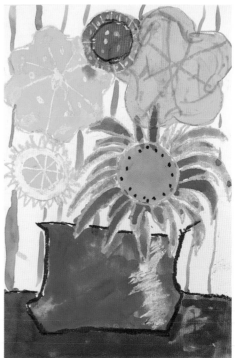
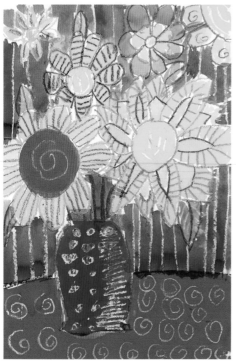
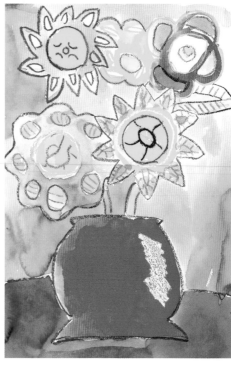

VAN GOGH FLOWERS

Learning how to draw sunflowers in the style of Vincent Van Gogh was a staple in my art room. Every year, my second- and third-grade students learned a few simple steps to draw the complicated mass of sunflowers as shown in Van Gogh's sunflower series. To make the drawing less complicated for a 5- or 6-year-old, start with some type of circle or flower template, like a baby food jar lid or yogurt container top. Don't feel like this is cheating. My philosophy with templates is that sometimes they help a child get through a part they may find a bit challenging (drawing circles) to the fun part: wax resist.

THE SETUP

I like using liquid watercolors over tray watercolors for this lesson because you need a lot of paint for this size of project. Liquid watercolors offer children an easy way to get a lot of color on the brush. You can dial up the intensity or water it down.

Give each child a black waterproof marker or oil pastel and a piece of 12" x 18" watercolor paper. If you use a waterproof black marker or a small selection of oil pastels, limit the color choice. If you set out two or three colors instead of a whole box, the drawing will be more cohesive. I often offer just black for drawing and white for details.

what you'll need

- 1 sheet of 12" x 18" white watercolor paper per child
- Liquid watercolor paint
- Black oil pastel (for ages 8 and under) or black waterproof marker (for ages 9+)
- Medium-large brush
- White oil pastels for details
- Round plastic lid to help small children trace the flower center

what you'll learn

- How to draw a vase of flowers
- How to blend watercolor paints
- How wax resist works

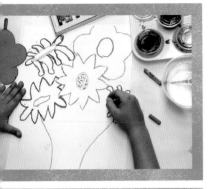

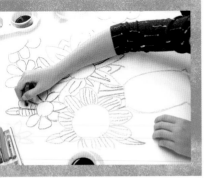

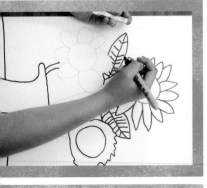

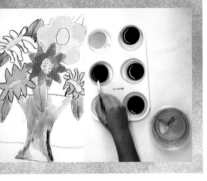

THE PROCESS

Before the watercolor fun begins, you have to draw something. Draw the bottom of the vase first. Make sure to leave some space between the bottom of the vase and the bottom edge of the paper. Draw the sides of the vase, but leave the top open for now. Draw a table line, hopping over the vase and extending the line off the other side.

Draw the flowers. For younger children, I used a flower template (see page 49) so that little ones can create a large-scale drawing, which is easier for them to paint than a smaller drawing. For older children, draw five to seven circles and flattened ovals above the vase. Make sure to space out the flower centers so that there is room for petals. Pick one flower center to be the dominant flower. Add petals around the circle. Van Gogh painted sunflowers at all stages of decay. Some of the flowers are painted with very few petals. You can decide how many petals your flowers have. Some flower centers may feature many petals, drooping petals, or no petals at all. Fill in any empty spaces with leaves.

If using the black marker, it's helpful to use a light-colored oil pastel to trace just outside of the marker line. This helps create a wall for the watercolor paint and reduces the amount of bleed that happens when wet paint touches wet paint. To mimic Van Gogh's style of textured brush strokes, children can add short pastel strokes on and around the flowers, vase, or even tabletop.

After the drawing is done, set out a tray of liquid watercolors. Try to clean the brush between colors, but don't worry if a child accidentally places a dirty brush into a clean color—it's hard to keep liquid watercolors pristine when children are involved. If this happens, delight in the wonderful colors that emerge from the accidental mixing.

Children have a way of adding their own touch to the artwork even when instruction is offered. Some of my workshop kids added splatters, dribbles, and crayon patterns to their flowers. This is the result of playing with the paints and makes for the most beautiful results.

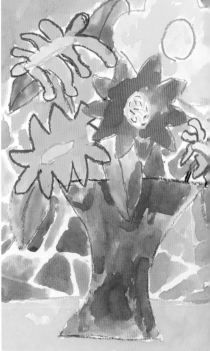

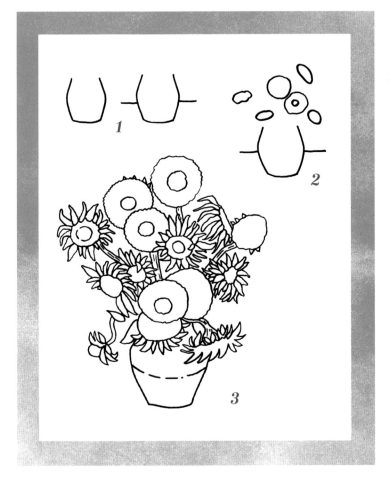

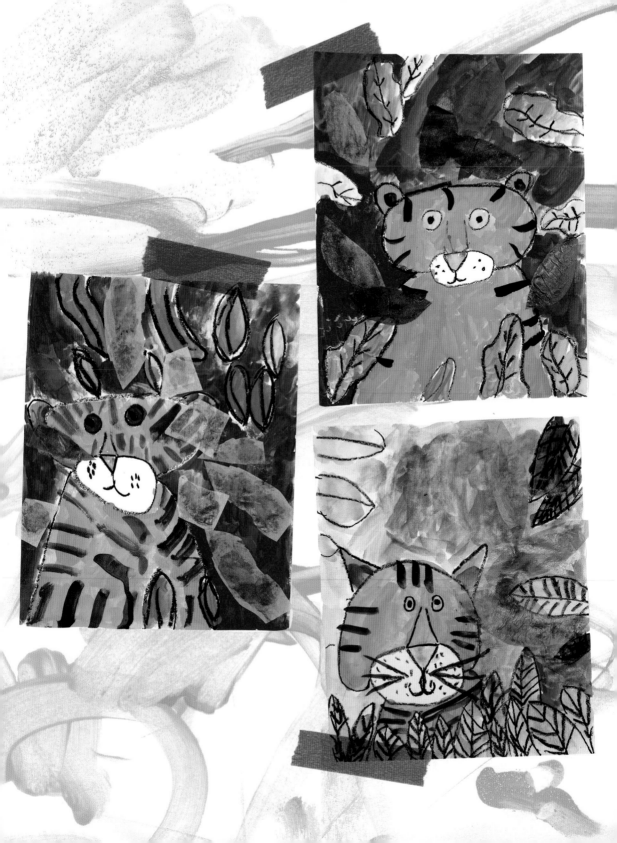

HENRI ROUSSEAU JUNGLE TIGER

Henri Rousseau was a self-taught artist who worked very hard on his craft. For years, Rousseau practiced his drawings after work at his job as a tollbooth operator. At first, Rousseau's work was laughed at for looking too much like a child's drawing. Eventually, artists came to appreciate his art and encouraged him to keep trying.

Rousseau's determination is an inspiring story and his art is equally appealing to children. One of his most famous paintings, Surprise!, features a tiger jumping out from behind jungle foliage. Drawing a hidden tiger is a great place to start this Rousseau-inspired art project.

THE SETUP

This project has a few easy steps. Start with a 12" x 15" white piece of paper and a black oil pastel. You'll draw and paint the tiger first and then create the background. Cake tempera paints are perfect for this type of project as the colors are rich yet transparent enough to see the details of the drawing. If your paint cakes are muddy, don't worry. Clean them with a wet sponge or place them under running water. You'll add tissue paper with a bit of Mod Podge at the end to create an even more dynamic piece of art.

THE PROCESS

Use the drawing steps to guide children in drawing the tiger. The tiger's face is created with a series of shapes and lines that even the youngest child can master. Start by drawing two dots for the eyes in the middle of the paper. Add a circle around the dots to complete the eyes. Below the eyes, draw an upside-down triangle for the nose. To draw the bridge of the nose, place

what you'll need

- 1 sheet of 12" x 15" white drawing paper per child
- Cake tempera paint tray (orange, green, yellow, and blue)
- Black liquid tempera paint for the tiger's stripes
- Medium-large size round brush
- Green tissue paper (non-bleeding type)
- Mod Podge or watered down white school glue
- Black oil pastel

what you'll learn

- How to draw a tiger
- How to use tissue paper and Mod Podge to create a jungle
- Why warm and cool colors are important in art

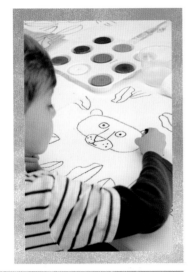

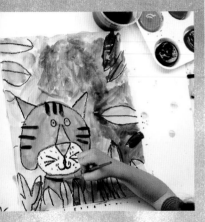

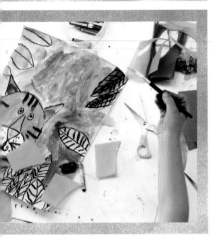

the oil pastel between the eyes and draw an angled line from between the eyes to one side of the triangle nose. Do the same to draw the other side of the bridge. To draw the mouth, place the pastel on the point of the upside-down triangle and draw a letter *J*. Repeat with a backward *J* for the opposite side of the mouth. Create the muzzle by placing the pastel on the top side of the triangle nose and drawing a curved line below the mouth and all the way to the other top triangle.

To complete the head, place the oil pastel on one side of the muzzle and draw a curved line up and around the eyes, coming back to the other side of the muzzle. The ears are half circles placed on the upper top part of the head. There's no need to draw a body just yet.

To make the jungle, draw a series of leaves around the tiger's head, placed in various angles on the background. To draw a leaf, draw the stem first. Then, place the pastel at the tip of the stem and draw one curved line toward the edge of the paper. Repeat on the other side. Some leaves can be thick and others can be thin. Create movement within the leaves by drawing the stem line curved, not straight. Encourage your artist to draw as many leaves as they want.

Connect the head to the outline of the leaves by drawing two lines for the body. This is all you will likely need to draw for the body.

Now it's time to add paint. Start by swirling a medium round brush (not too small or young children will tire of having to return to the paint tin too often) in the orange cake or pot. Swirl until you see the color on the brush. Younger children often tap their brushes on the cake and will not pick up enough color.

Paint the tiger orange, add black stripes, and then move on to painting the leaves. I showed my artists how to mix colors together by swirling the brush on the yellow, then immediately swirling onto the green.

The resulting lime color is beautiful and children can see the potential to have more than one color of leaves.

It's important to show kids how to paint the background in "cool" colors and the tiger in a "warm" color, which helps the tiger pop from the paper. If the background were the same warm color as the tiger, the tiger wouldn't be as noticeable.

To keep things simple, paint the background one color. Set the painting aside to dry.

When the paint is dry, re-trace over all the oil pastel lines that are covered with paint. This really sharpens the colors. This is a good time to add veins to the leaves with the black oil pastel.

Complete the painting with some additional details. Tissue paper and Mod Podge add an interesting layer to the artwork. Stack squares of green and yellow tissue paper and cut the stack into leaf shapes. Decide where on the artwork you want to place the leaves. Brush Mod Podge on the area, place the tissue paper on top, and then brush another layer of Mod Podge over the leaves to secure them. I call this a Mod Podge sandwich.

tip

If you don't have Mod Podge, use regular white school glue watered down a bit. Place in a plastic container and use an inexpensive brush to apply glue to paper.

What are warm and cool colors? Warm colors are those that remind us of sunshine and fire. Cool colors remind us of cool places like the sea and forest. Painting the tiger in a warm color and the background in a cool color helps the tiger pop from the paper.

1

2

3

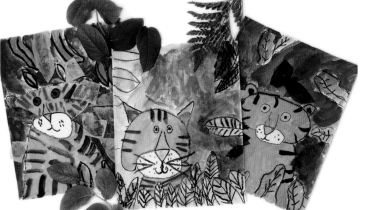

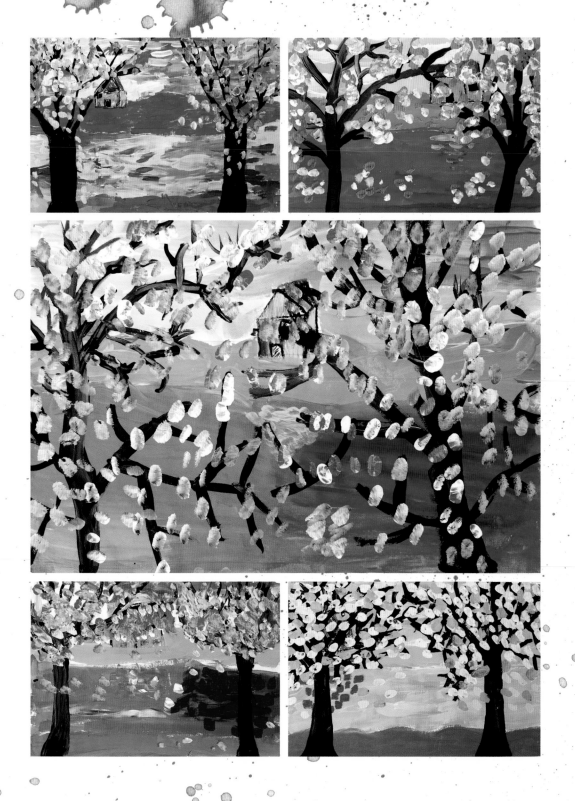

CLAUDE MONET SPRING LANDSCAPE

I love projects that look detailed and slightly complicated but are actually very easy to create. When you first look at Monet's painting The Isle Grande-Jatte, *it looks rather fussy and daunting, especially to kids. While not many kids get excited about painting a landscape, the painting techniques in this project are super engaging. We will focus on two of my favorites: the double-loading technique and stippling.*

THE SETUP

Give each child one sheet of paper and access to a tray of oil pastels and paint palettes. Under each paper, place a large paper placemat; children can use the placemat to clean their brushes without using water. Place the following colors of liquid tempera paint into a muffin-style palette: white, yellow, green, turquoise, blue, green, and red. It's okay to put two colors in one well as long as they belong to the same color family, i.e., royal blue with turquoise.

THE PROCESS

The painting starts with a drawing. I used oil pastels, but crayons are fine, too. On a white sheet of paper, draw a straight horizontal line in the middle of the paper. This is called the horizon line and it separates the water from the land. Then, draw a wavy or curved line over the horizon line for a hill. Add a few simple homes and barns with oil pastels. Keep the shapes simple, but color them in solid with the pastels.

what you'll need

- 1 sheet of 12" x 18" white drawing paper per child
- Liquid tempera paint or acrylic craft paint in a variety of colors
- Black liquid tempera paint for drawing trees
- Medium and small brushes
- Colored oil pastels or crayons for drawing houses

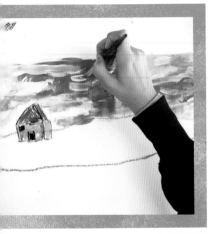

With the oil pastel drawing complete, turn to the paint. Monet often used yellow tones in the sky. This works well as it helps distinguish the sky from the water. To do this, select a color from the paint palette, scoop up a small amount, then scoop up another complementary color. Paint the combination of the colors directly on the paper. Try not to use water, as this will dilute the intensity and creaminess of the paint.

Paint the hills a muted green color. Mix yellow and green and allow whatever color is on your brush to mix in with the grass color. This creates an interesting shade. Again, resist the urge to wash your brush. If you need to remove some of the paint, run the brush along the paper placemat a few times until no paint remains. This is clean enough!

Paint the water using white, blues, and greens. Monet painted with choppy strokes. To mimic this style of painting, dab the loaded brush onto the paper in an up-and-down motion. Note: Older kids will have more patience for this than younger children.

To make the reflections in the water, copy the colors of the buildings to make dappled marks in the water. Use horizontal strokes and mix as you go. Paint the area below the water with green mixed with blue paint or green mixed with yellow.

Finally, add some trees to the painting. Use a small brush and the black tempera paint to draw the silhouette of the bare-leaf trees. Two trees are great for the larger paper. Starting at the bottom of the paper, paint a tree trunk and three limbs: one straight up and two limbs extending from each side of the trunk. The limbs can bend and sway off the paper's edge and toward the center of the page. Add lots of branches. It may help to turn the painting upside down so you can create skinny tree branches. When you have enough branches, set the painting aside to dry.

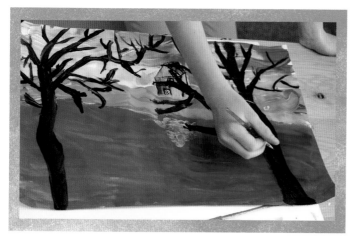

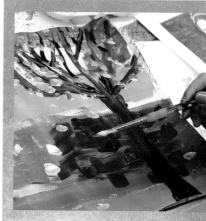

Once the black paint is completely dry, dip a medium round-tip brush into white paint with a dab of red paint. Dab paint (cherry blossoms) all over the tree branches. The closer you dab the blossoms together, the more background you will cover. Round brushes pressed onto paper make the perfect leaf shape. Show children how to dab the brush up and down and in different directions to fill the trees with leaves. Children enjoy creating blossoms that are pink, red, and white. You can add blades of grass using a small brush. Try mixing a bit of dark blue or even black paint with the green to make dark grass strokes.

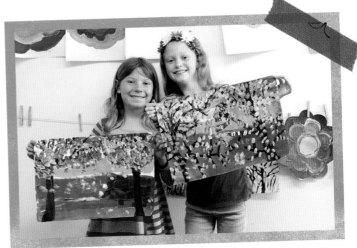

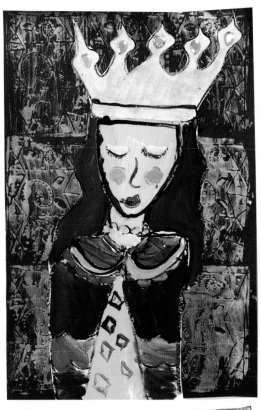
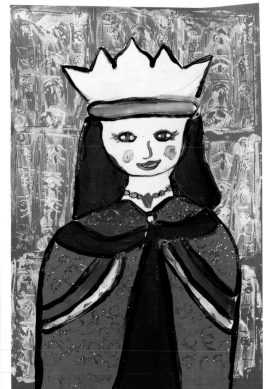
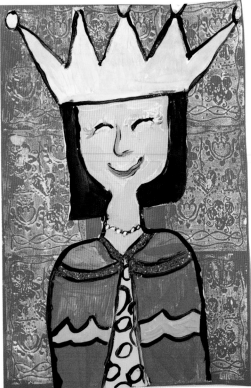
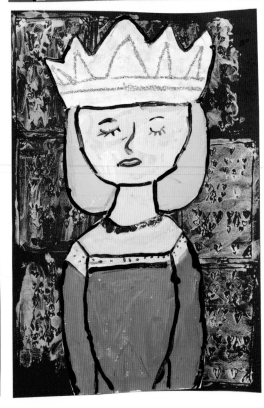

GEORGES ROUAULT PAINTED AND PRINTED ROYAL FIGURES

French painter Georges Rouault began his career as a glass painter at only 14 years old. This influence is probably why many of his paintings feature a strong black outline. He was famous for his painting Old King, which features expressive lines, dark rich color, and his trademark heavy outline.

This project simplifies the drawing by separating the background from the figure. While this step is optional, creating a metallic jacquard background is a great opportunity to introduce printmaking and create an opulent backdrop.

Georges Rouault painted royal figures

I taught variations of this lesson for many years to my kindergarten through fourth-grade students. Both boys and girls can adapt the drawing depending on their interest level.

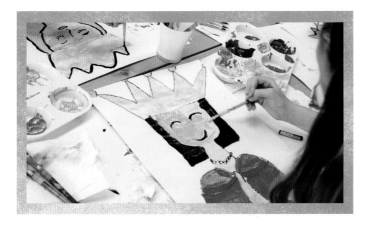

what you'll need

- 1 sheet of 12" x 18" white drawing paper per child
- Black oil pastel or crayon for drawing
- Liquid tempera paints
- Craft glitter
- Black liquid tempera for outlining
- White school glue
- Small and medium brushes
- Craft rhinestones or jewels

- How to create luminous colors with the double-loading technique
- How to paint without cleaning your brush
- How to draw a crown

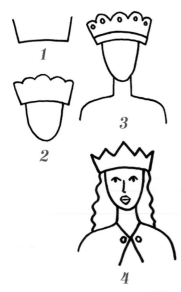

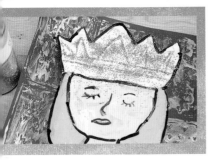

THE SETUP

This project starts with the drawing and painting of the royal figure. Start with a piece of regular white drawing paper and a black oil pastel or crayon to create the drawing.

THE PROCESS

Drawing the crown first is a great way to help a young artist draw a head large enough to be painted. With the black oil pastel or crayon draw a horizontal line on the top half of the vertically placed paper. This is the bottom of the crown. Make sure to leave room for the top half of the crown.

Draw the two sides of the crown next. Finish the crown by drawing the outside or contour lines of the crown top. Don't add the crown details yet. Wait until after the painting dries to do that.

To add a face, place the oil pastel inside the outside edge of the crown and draw a letter *U*. Finish just inside the other edge of the crown. The idea is to keep the lines simple and shapes large so that the painting later is easy. Don't add any facial features yet.

Draw a neck, then stop. At this point, you'll want to think about what type of garment you would like your king, queen, or princess to wear. My suggestion is to keep it very simple by drawing a cape. Place your oil pastel on one side of the neck, draw a line toward the side edge of the paper, and turn toward the bottom. Do the same for the other side of the neck. For the cape opening, draw a dot below the neck. Connect this dot to both shoulders to create a neckline. Draw the cape open or closed simply by drawing one line (closed) or two angled lines (open).

Go back to the bottom edge of the crown and draw wavy hair or straight hair, short or long.

Next we're going to use the double-loading painting technique to paint our figures. Start by painting

the skin color. Dip the brush into the white paint and then some orange, brown, or even yellow paint. Paint onto the face shape and see what happens. Too orange? Add more white. Too light? Add more brown. The colors aren't meant to mix perfectly. It's lovely to see a bit of both colors on the paper.

Paint the cape next. Choose any combination of colors, but use two colors that blend well with each other or form a new color. For example, red and purple make a vibrant violet. Add a touch of white and the violet turns into fuchsia. Don't underestimate how fun this exploratory process is. This technique will captivate kids for a good 45 minutes!

Continue painting every area of the royal figure. After adding all the colors, trace over the pastel lines with a small brush dipped in black paint. Add the facial features, crown details, and embellishments to the clothing with the black paint.

To add a glamorous touch, use white school glue and glitter to add bands of shimmer to the crown or to any part of the dress. Use the glue bottle like you would a pencil: draw designs, dots, or patterns directly over the dry paint. Sprinkle glitter over the glue and shake off the remaining glitter into a trash can. If you have plastic rhinestones, add them to the crown or use as jewelry.

Allow the figure to dry, then cut it out and set it aside while you create the jacquard printed background.

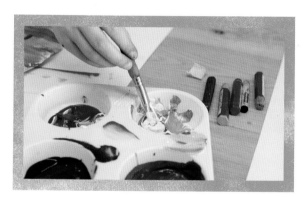

DOUBLE-LOADING PAINTING TECHNIQUE

This is my favorite technique for mixing paint colors. The benefit of this technique is that it eliminates the fussy paint mixing that some art projects begin with. Mixing paint takes time, and the longer any step takes, the less likely a child will finish it. The double-loading painting technique is quick, magical, and beautiful.

To start, dip your paintbrush in one paint color and scoop up a tiny amount. With the same brush, dip into another color. White is often a great first choice. With the two colors of paint on your brush, apply it to the paper. Try not to blend the two colors together too much. It's wonderful to see both colors mix and mingle directly on the paper.

- 1 sheet of 12" x 18" dark-colored drawing paper per child
- Pencil
- Gold or bronze metallic tempera paint or acrylic paint
- Flat brush
- Foam printing sheet or meat/vegetable Styrofoam tray (make sure to clean well in soapy water before using)

what you'll learn

- How to create a relief print with foam and paint

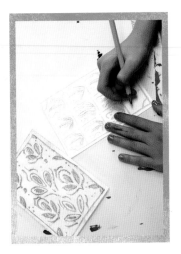

jacquard printed background

Drawing on a foam vegetable tray or printing foam is a fun experience for kids, and this printing technique creates an opulent background for our Rouault-inspired royal figures. Jacquard, a fabric that features ornate woven designs, is considered a fancy fabric perfect for royal kings and queens.

THE SETUP

Select a piece of foam around 4" x 3". You can purchase printing foam or raid your trash can. The foam needn't be thick. Thin sheets will do the trick. Use metallic liquid tempera or acrylic paints. If you have printing inks and brayers, all the better, but it's not necessary.

THE PROCESS

Using a dull pencil, draw a border around the foam. If the pencil is freshly sharpened, the lead might tear through the foam sheet, so make sure you wear the lead down a bit. Draw designs onto the foam, pressing hard enough for the pencil to indent the foam. (See the sample designs on page 63.)

The whole concept of relief printmaking is that the area of the foam that is pressed down by the pencil *will not* be covered with paint. When you paint over the foam and press the foam paint-side down onto colored paper, the design will show on the paper.

Select a dark blue or any dark-colored sulphite paper to contrast with the gold and bronze liquid metallic paint. Paint the etched foam with a dry flat brush dipped into paint, being sure to cover the entire surface.

If using metallic tempera paint, it's important to note that the paint will not look as though it is covering the foam well. I don't know why this is but as soon as you press the painted foam onto the dark paper, it looks great. If you can see the brush strokes on the paper, just add another layer of paint to the foam but this time brush in a different direction. Continue printing on your paper until it is completely covered.

When your jacquard print is dry, glue your royal figure on top.

tip

I strongly recommend trying this printing process before introducing the concept to children. When you practice the etching with the type of paint you have on hand, you'll understand how it works. Then, when you work with your kids, you'll be able to impart your knowledge.

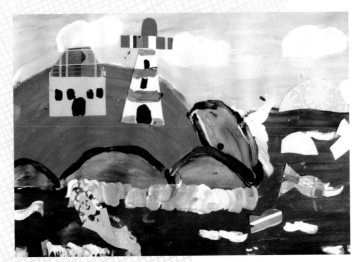

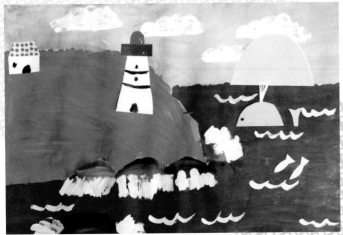

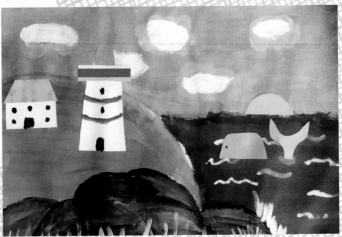

MAUD LEWIS LIGHTHOUSE

Maud Lewis is one of my favorite painters. She was born in Nova Scotia, Canada, in 1903 and loved to paint scenes depicting the maritime lifestyle. Born with juvenile arthritis, Maud's hands were crippled. In order to paint, she had to steady one hand with the other. This didn't stop her, as she used every available surface in her small home as canvas. Her paintings remind me of my childhood home in Atlantic Canada; the fishing boats coming into harbor, the fields and farms, the cows and cats—all of these scenes were part of my life as a young girl.

What I love most about Maud's paintings is the childlike quality of her work. She plucked the discarded paint cans from the shipyard that were used to paint the lobster boats. She stored the discarded paint in sardine cans to create her color palette. As a result, her paintings are bright and colorful. They also lack perspective, shading, and basic rules of nature. But that's what makes her paintings some of the best-known and loved folk art in Canada.

THE SETUP

This project works equally well with both liquid tempera paint and acrylic paints, so use whatever paint you prefer. You can do the project in one sitting or break it into two parts: the background painting and the paper details. The lighthouse, boat, and buoys are all created with craft paper. Use the drawing guides for a general outline or create your own.

what you'll need

- 1 sheet of 12" x 15" white drawing paper per child
- Liquid tempera or acrylic paints (white, red, blue, turquoise, green, black, yellow)
- Black and colored oil pastels
- Small and medium brushes
- Pencil and black marker
- Scraps of white paper and colored craft paper
- Scissors
- Glue

THE PROCESS

With a pencil, lightly draw a hill on the left-hand side of the paper. Draw the horizon line (where the ocean meets the sea) starting one-third of the way down from the top of the hill to the other side of the paper. Draw a series of curved lines for rocks at the bottom of the hill. The rocks can extend off the bottom of the page or not.

Using liquid tempera or acrylic paints and a small brush, outline the rocks with black paint. Then, without cleaning the brush, dip it into the white paint and allow the mixture of white and black paint to blend into gray for the rock colors.

Use a combination of white and blue to paint the sky. Use a different combination of blue (perhaps blue and green, or blue and black) to paint the ocean. Add whitecaps and white clouds to the sky using white paint. Paint around the rocks, then paint the green hillside.

On colored or printed craft paper or painted paper (see page 67), draw a lighthouse using a pencil. I try to encourage the kids to draw on the back of the paper so after they cut out their object, the pencil line won't show on the good side. Guide children in drawing the lighthouse. Try not to show the kids every single step in creating a lighthouse, as you want them to think about the process. I like to draw a few simple shapes on a piece of paper to show students how they might approach the basic structure of a lighthouse, but allow them to figure it out. Draw details like portholes, doors, and windows with a black marker.

To complete the art, consider adding fishing boats, seagulls, buoys, a sun, or even clouds to the artwork. Use the same technique as the lighthouse to create these objects.

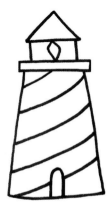

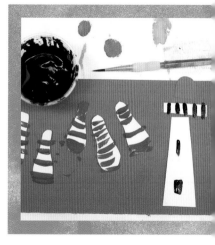

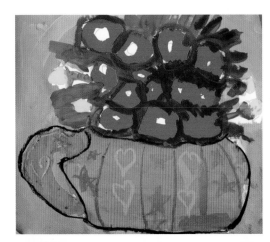

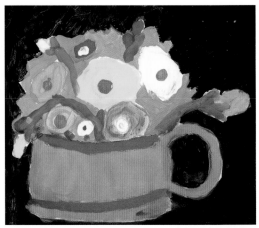

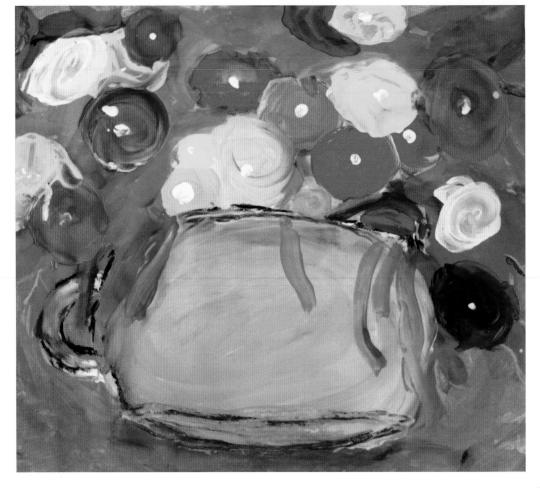

CLEMENTINE HUNTER STILL-LIFE FLOWER ARRANGEMENT

American folk artist Clementine Hunter was the first African-American woman to display her work in the New Orleans Museum of Art. Because of segregation laws she could only view her works after hours. Her love of flowers, especially zinnias, inspired her to paint every day.

Painting a still-life flower arrangement can be an incredibly satisfying project to do with your child. Flowers are easy to draw and even easier to paint. In fact, you don't even need to use a pencil. I like using a soft chalk pastel or even a light-colored oil pastel to draw. Drawing the shapes with a thick drawing tool like the pastels encourages children to draw big and loose compared with small and detailed. We want large shapes because we are working with paint to color in the flower shapes.

THE SETUP

Liquid tempera paint is my favorite mixing paint. It is easily blended and is widely available. I like to squirt six different colors of liquid tempera paint onto a paper plate or plastic paint palette. You can pick colors based on what you like, or you can look at a flower arrangement and select the colors that you see. Select one color for the pot, one color for the background, and four colors for the flowers. Make sure to include white paint. It's a great mixing paint that transforms basic colors into pretty pastels.

what you'll need

- 1 sheet of 12" x 18" white drawing paper per child
- Liquid tempera paints (white, red, blue, turquoise, green, yellow)
- Light-colored chalk pastel or oil pastel for drawing
- Medium round brush
- Colored chalk pastel for adding details

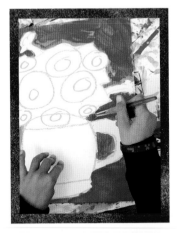

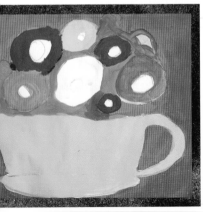

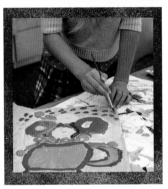

Cut a piece of 12" x 18" paper down to a 12" x 15" size. This helps keep the painting centered on the paper. Feel free to place the paper in a vertical or horizontal position.

THE PROCESS

You may not think it's necessary to give instructions for drawing a still life, especially one as simple as a few flowers in a pot. But my experience has proven that when children are given a few simple instructions, their imaginations are free to create great things. Demonstrating where to draw the lines that will form the vase and the flowers allows the child to experience a great start to their drawing. This eliminates the struggle that many young artists face when staring at a blank piece of paper.

Keeping this in mind, show the children that the top part of the paper is reserved for the flowers and the bottom for the vase. Guide children in drawing the flower arrangement. Use a piece of light-colored chalk pastel or oil pastel to draw two curved lines for each side of the pot. Draw a slightly curved line for the bottom and the top of the pot. Add handles if you like. Each handle looks like the letter *C*. Make sure to double the lines to create a shape that you can paint.

To draw flowers, decide how far apart or how big you want to make the flowers. Draw the small circles for the flower centers first. A good way to make sure you have enough room for the flower petals is if you can fit four fingers between each flower center. To create zinnia-like flowers like Clementine Hunter's, draw large wobbly circles around each flower center. The bigger you make the flower, the bigger the area is to paint. Add leaves in between your flowers to fill up any empty space.

Dip a medium round paintbrush into one color of paint and paint the background. Brush carefully around the pot and flowers. Paint as close to your chalk or pastel line as possible. Clean your brush by wiping the brush onto a paper placemat. No need for water. Less water creates more vibrant paint colors. Dip the brush back into the paint and paint your flowers. Each flower can be a different color or they can be the same. The flower paint should cover the pastel drawing lines and a little bit of the background paint. Pick one color for your pot and paint the body and handles.

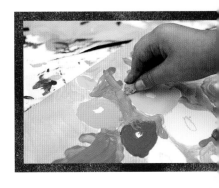

After the paint dries, add the finishing details like shadows and highlights with soft chalk pastels. One of my favorite combinations is using soft chalk pastel over dry tempera paint. It's a great opportunity to add colorful details. Pick a soft chalk color a little darker than the color of the pot and trace around the outside lines. Use your finger to blend the hard lines. This is called adding a shadow. Sometimes the shadow is stronger on one side of the pot or vase and where the pot touches your table.

You can add a reflection (where the light source hits the pot or vase) by using white chalk. The reflection is often opposite of the shadow and sometimes it is drawn in the middle of the pot. Color in the centers of the flowers. If you have any white or unpainted space between your flowers, you can use either chalk pastel or green paint to add leaves or flower buds to your painting.

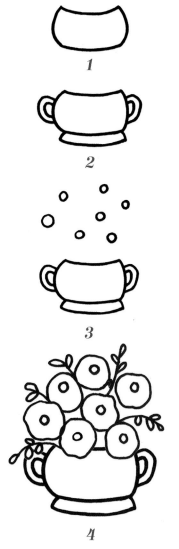

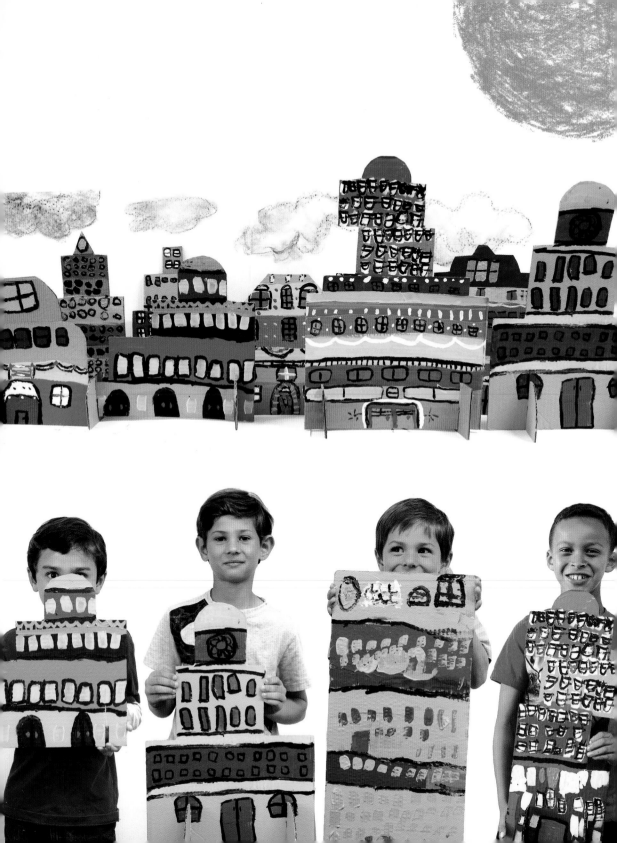

JAMES RIZZI CARDBOARD CITY

As a child I remember dragging boxes from our basement up to my bedroom. The boxes became side tables, bookshelves, homes for my dolls, and pretty much anything I could think of. To me, a cardboard box represents possibilities. Today, not many kids look at cardboard boxes with as much excitement. But once you break down the box, section it into large rectangles, and start creating skyscrapers, ideas begin to sprout.

My students looked at the art of American artist James Rizzi for inspiration for these colorful cardboard buildings. Rizzi's illustrations, especially scenes from New York City, capture creative color combinations and comic-like details.

THE SETUP

For this project, it helps to have a few building pictures handy. James Rizzi's official website (www .james-rizzi.com/en/) is a great resource to see his colorful building paintings. If you live in a city, the best way to see how buildings are structured is to go on a walk and look around. Encourage children to observe how the buildings are layered. What is included on the first floor? How many doors? How many windows? Is there an architectural detail that separates the floors? How tall or wide is the building compared to other buildings? These questions will really help children see the many layers and details in each building.

what you'll need

- Collection of corrugated cardboard broken into rectangular pieces
- Scissors or x-acto knife
- Acrylic paints
- Black acrylic paint for outlining details
- Medium and small flat-edge brushes

what you'll learn

- How to create a 3D city using stands
- How to make tints with acrylic paint

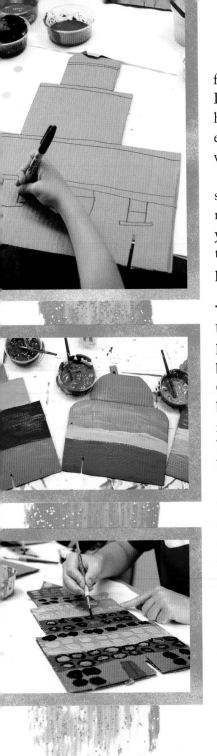

Break down a cardboard box and cut away the flaps. Open up the box and separate each side. Depending on the size of your boxes, you can decide how large or small to make the rectangles that will eventually become the skyscrapers. Offer your kids a variety of rectangular shapes between 12" and 36" tall.

Acrylic paints have the best coverage for cardboard surfaces. Because the colors are thick and vibrant, no primer is needed. If you don't have acrylic paints, you can use regular liquid tempera paints. Be warned, though, that the tempera paint will not cover any printing that is on the box and will crack when dry.

THE PROCESS

Use a marker or pencil to divide the skyscraper into horizontal sections. Some buildings might have a wide base, a narrow middle section, and a dome on top. Once the child has determined the silhouette of the building, an adult uses scissors or an x-acto knife to remove the excess cardboard. Cut two small slits at the base of the cardboard building to allow the stand to be inserted.

Use a ½" flat brush to apply a single color of paint to each horizontal section. I premixed acrylic paint colors making sure I had plenty of bright colors and softer colors. Paint the bottom section first, ignoring the instinct to paint around a door, followed by the remaining sections.

When the paint dries, paint windows, architectural details, molding, and doors. To paint windows, use a flat-edge brush and dip it into a light-colored paint. The brush width determines the width of the window. Apply the brush and gently move it down until the size of the window is achieved. Make as many windows as desired. Some windows can be wide, others narrow. Using the tip of the flat brush creates a skinny window. Use as many colors as you wish.

Add a door at the base and moldings on each building layer. Once all the details are painted, dip a very small brush in black acrylic paint and outline the windows and doors.

To add a stand, cut out a small 3" x 5" rectangle from the scrap cardboard. Cut a slit ¼" wide by 2" tall and insert it into the building slit. Children can paint the stand the same color as the base.

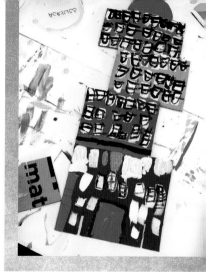

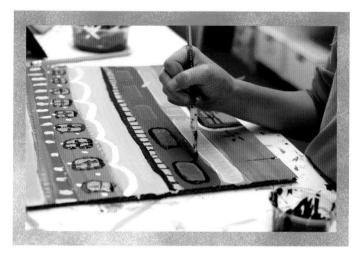

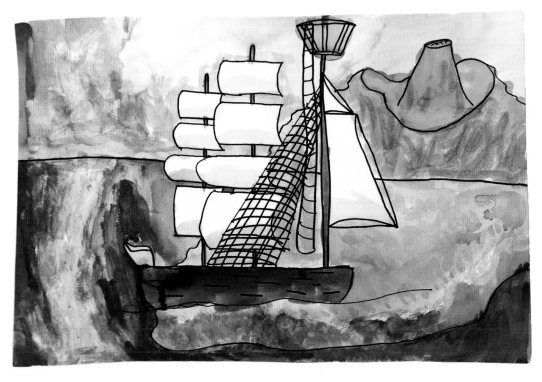

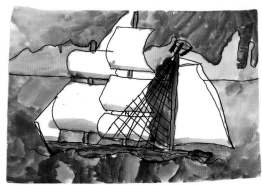

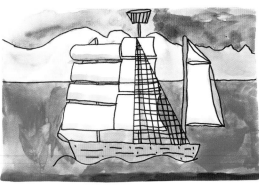

WINSLOW HOMER SHIPS

Clipper ships glide over the ocean at top speeds. The tangle of nets, ropes, and sails, however, can make drawing a sailboat or a clipper ship daunting. But if you break down the ship's parts into basic shapes and know what to draw first, the drawing becomes effortless. Use a combination of black waterproof marker, pencil, a homemade ruler, and an eraser for drawing the ship.

American artist Winslow Homer was a famous watercolor painter who specialized in seascapes. His paintings vividly show the ocean's many moods. Not always basic blue, ocean colors can range from kelp green to stormy gray to serene turquoise. When I teach a Homer lesson, I use orange and blue paint to create the stormy Atlantic seas so often the subject of Homer's earlier paintings.

THE SETUP

I use watercolor pans for this lesson because mixing paints to create unique colors is an important component of this project. If you don't have watercolor paper and paint, it's okay to use regular drawing paper and your choice of medium. You may want to consider using soft chalk pastels to color the background and ship.

THE PROCESS

Guide children in drawing the clipper ships. On a sheet of watercolor paper, draw a wavy line near the bottom of the paper to represent the ocean waves. Draw two angled lines for the ship's stern (back) and bow (front). Set down the marker and pick up a pencil. Grab a ruler or fashion a homemade version: cut a piece

what you'll need

- 1 sheet of 12" x 18" white watercolor paper per child
- Watercolor paints
- Pencil and eraser
- Black waterproof marker
- Medium brush
- Straightedge or homemade ruler
- Optional: Tissues and white tempera or acrylic paint

what you'll learn

- How to create shadows with watercolor
- How to draw a clipper ship
- How to use colors to express mood

of 12" x 18" colored paper in half and fold the paper; use the folded side of the paper as a straightedge.

With a pencil connect the top of the bow line to the top of the stern line. The bow line might be higher and that's good. Next, consider the ship's masts. Help student's gain appreciation for how tall the masts are by looking at some photographs of clipper ships. They are usually as tall as the ship is long. Place the ruler or straightedge perpendicular to the bow. Place the pencil near the top, but not at the edge of the paper, and draw a line toward the top line of the hull.

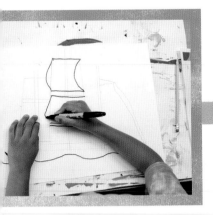

tip

Kids will have an easier time drawing a lighter line by pulling the pencil toward their belly button rather than pushing the pencil away from their body.

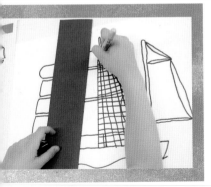

Draw another line parallel to the first line. This is the first of three masts. Repeat to create two more masts: one near the bow and one near the stern. To draw the sails, draw a horizontal line across the top and bottom of each mast, leaving just enough room at the top for a flag, crow's nest, and so on. Draw two angled lines extending from the sides of the top horizontal line to the top of the bottom horizontal line. Make sure to widen the shape as you move toward the bottom of the mast so it looks like a trapezoid. You can change the style of mast at the back of the boat as shown in the artwork.

Using a pencil, take a straightedge and divide the large sails into three or four sections by drawing horizontal lines directly over and perpendicular to the mast. Repeat for each large sail. Using a black marker, outline all the pencil lines around the top and sides of the hull, but avoid the bottom, sails, and mast. This can be tricky!

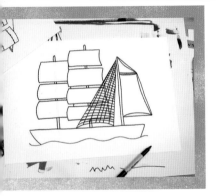

tip

Make sure to outline the sails before the mast to avoid drawing through the sails. The order of outlining is important:

1. Top and sides of hull
2. Sails
3. Mast
4. Add ropes/lines, netting, sails at the bow, wooden slates, and any other details

After all the details are complete, erase the pencil lines. Make sure to wait until the marker is dry or you may get some streaks. For the final step, draw a few horizontal, broken lines on the hull to mimic wooden slats.

Once the drawing is complete, begin painting with the watercolors. I begin by demonstrating how to mix colors in the cover of the watercolor case. I begin with the colors of the sea and show obvious pairings like blue and green (turquoise) but also interesting pairings like orange and blue (stormy gray), and blue and black (navy).

Encourage the kids to create atmosphere by using either bright or muted colors. Paint the sky and ocean first (avoiding the sails); once the paint dries completely, finish painting the boat.

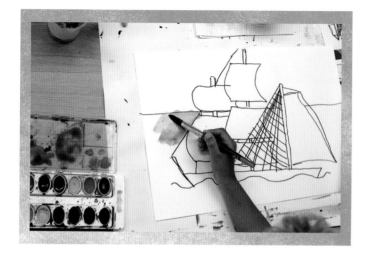

tip

It's much easier to paint the sky color directly over the thin rope lines. Unless you show kids this trick, many will paint around the ropes and fine sail lines.

When painting the sky, you can use a tissue to "lift" color. This technique is perfect for creating clouds. While the paint is wet, scrunch up a tissue and dab it over the blue paint. Remove the tissue. The blue paint will lift away revealing a white space. This is a cloud. Leaving the clouds white is the natural tendency for children, but clouds can also be full of color. Add a dab of light yellow paint on the bottom half of the cloud to warm up the painting. Most kids will love it and will become somewhat more adventurous on their own. Of course, having a few Homer paintings available to show also helps.

Waves have variety as well. How a child draws the waves (rolling, jagged, or none at all) will depict the mood of the art. Encourage combinations of blue and green, orange and blue, blue and dark gray, or blue with purple. Add whitecaps with white tempera or acrylic paint.

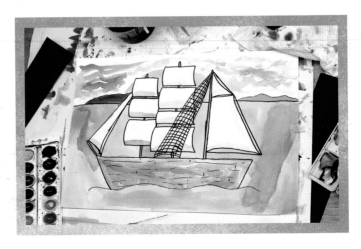

Paint the waterline of the boat. Children have a tendency to paint the water at the hull bottom line. To make the boat look like it is sailing through the water, paint the ocean color on one-third of the hull.

Creating realistic colors for the sails is tricky. A touch of brown and a touch of black mixed with plenty of water creates the perfect beige sail color. Of course, some kids have their own idea of what color they want their sails to be. Whatever they choose, encourage plenty of water so no matter what color the sails end up, they will be light enough to see the drawing details.

Paint the hull a darker color. Maintain the waterline so the boat looks as though it is sailing through the water.

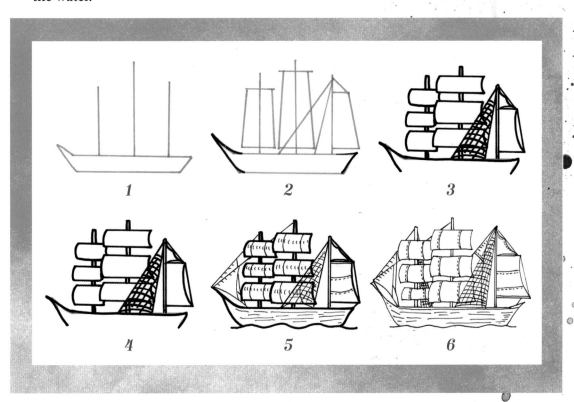

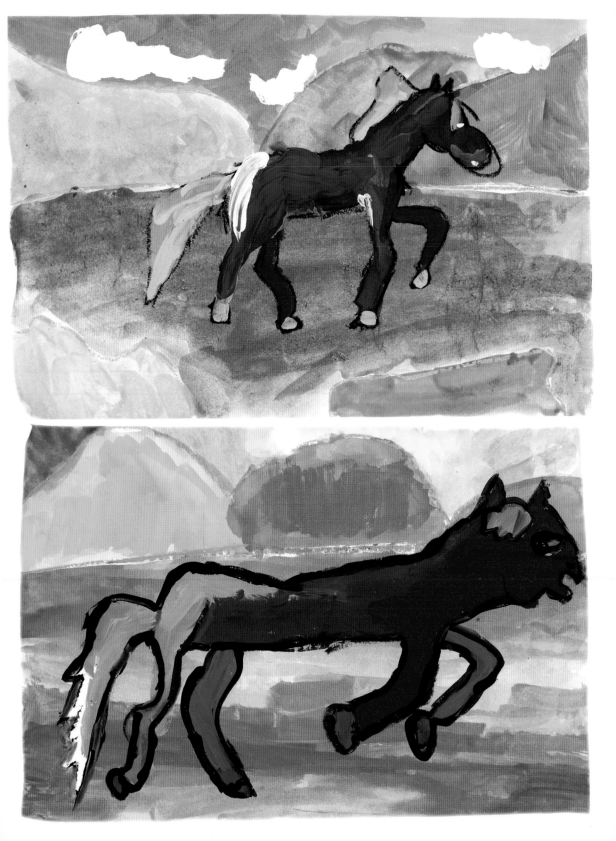

FRANZ MARC BLUE HORSE

Franz Marc was a German expressionist painter. He believed in using colors and choppy lines to make sense out of the world. He is best known for his painting style, which uses sharp lines and unusual colors to detail the emotion in his art. Children love seeing how an artist intentionally painted an object an unnatural color. This concept frees them up to focus on the fun of art and let go of the serious nature of "getting it right."

Eric Carle made Marc's painting known to many children in his book The Artist Who Painted a Blue Horse. *My students used the illustrations in the book to inspire their own painting.*

THE SETUP

I used cake tempera and liquid tempera paints for this project, but you could use acrylic paints if you prefer. For either type of paint, use plain white drawing paper.

THE PROCESS

Start the drawing with a horizontal horizon line with a light-colored oil pastel. I like to use yellow or light blue as it is covered well by most paints.

To draw the background, start at one side of the paper and add hills, mountains, clouds, shrubbery, and any other details. Keep the shapes big and spacious. Wet the cake tempera paints in advance with a few dabs of water to kick-start the color. Swirl a paintbrush around the cake until you can see the color on the brush. Paint the landscape with a variety of colors. Instead of a blue sky, why not a green sky mixed with yellow? Instead of a green meadow, why not shades of

what you'll need

- 1 sheet of 12" x 18" white drawing paper per child
- Light-colored oil pastel
- Cake or puck tempera paints for the background
- Blue, black, and white liquid tempera paint for the horse
- Medium brush

what you'll learn

- How to create tints with white paint
- How to make an expressionist painting
- How to use observation techniques to draw a horse

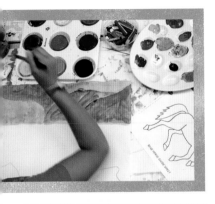

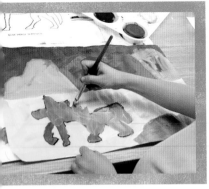

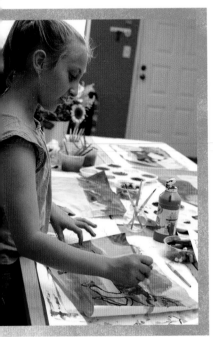

pink? Expressionist art means that the artist uses colors that are not typical for the subject. Children love when you give permission to use any color they like!

Show children Franz Marc's painting *Little Blue Horse* or *Blue Horse*. Draw a horse anywhere on the paper. Children can decide to draw their horse from a frontal view or a side view. My students chose the side view, as it is easier to identify the shapes that make up each section of the horse. Remind the children that they will paint the horse, so drawing a large horse is better than a small horse. The best part of this lesson is that the horse doesn't have to look realistic. Notice that the head is like a flattened oval, and the body is like a rounded rectangle. If you struggle identifying a shape, use your finger. Trace your finger around the outline of the horse's body. What shape emerges? Draw that shape. Remember: this is a painting that uses unusual colors. Children can make their drawings unusual too!

Using the liquid tempera paint, mix a dab of blue paint with a dab of white paint. Apply color to the horse. Continue painting the horse in as many shades of blue as you desire.

If you notice that the paint has made a mess out of the drawing, don't worry. You can tidy up the artwork by outlining the drawing with black paint and a small brush. Trace over all drawing lines. This is an effective technique to help distinguish sections of the art from each other. It is also effective in making colors pop!

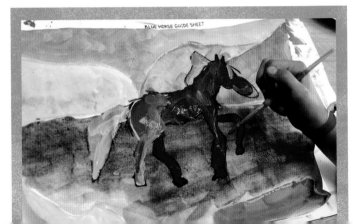

PAINTING WITHOUT WATER

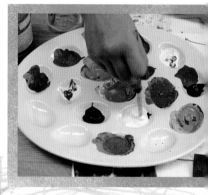

Sometimes parents notice that the colors in their child's artwork are not as vibrant as they expected. While paint quality can be a factor, most of the time it's a matter of using too much water. How can you paint without using water?

Fill three sections of a Styrofoam egg carton or a paper plate with a quarter-size dollop of any color of tempera or acrylic paint. Start with a dark blue. Squeeze a quarter-size dollop of white paint into one of the blue sections. Put slightly less white paint into the next blue section and just a touch of white paint into the last of the three blue sections. Take a paintbrush and mix the white and blue paints together. Notice how each section of blue is a different color? Repeat the steps to mix shades of red and white, yellow and white, green and white, etc. When you are done, you'll have a rainbow of colors.

Apply the lightest color of paint first. To switch colors, run the brush across a paper placemat a few times to remove most of the color, then dip the brush into another color and start painting. By taking the focus away from cleaning paint off the brush, the child's attention is on mixing and combining colors.

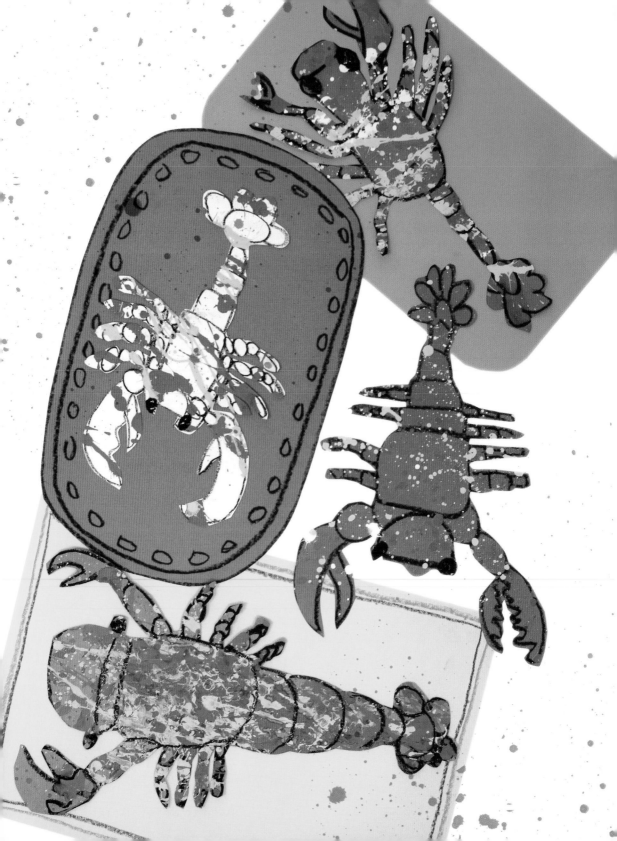

JACKSON POLLOCK SPLATTER PAINTED LOBSTER

Jackson Pollock is famous for his splatter paintings. The stream of browns, grays, blacks, and cream paint over a wall-size canvas is impressive to see. For most kids, one look at Pollock's paintings and suddenly art doesn't seem so hard.

I love re-creating the experience for a child where they can literally make a mess. For the parent at home, a splatter box can make the difference between a frustrating experience and an enjoyable one. The trick to making splatter painting work is by adding some water to the tempera paint. You're looking for the consistency of heavy cream. This allows the paint to dribble easily.

While making the paint-splattered art is fun, combining the painting with a drawing makes for an interesting piece.

THE SETUP

Showing a child a picture of a lobster (or the real thing!) and then asking them to draw it can be a real challenge. This is when a guided drawing is a great approach. Showing children how to connect a series of lines and shapes proves that they can draw most anything.

For the drawing, each child should have a colored piece of paper and a black oil pastel. After the drawing is finished, they head to the splatter box for some Pollock-inspired paint fun!

Splatter boxes are super easy to make. Take any large corrugated cardboard box, flip it on its side,

what you'll need

- 1 sheet of 12" x 18" red, white, or blue drawing paper per child

- Liquid tempera paints for splatter painting (red, blue, white, etc.)

- Black oil pastel

- Medium brush

- Scissors

- Optional: 12" x 18" colored paper for plate background

remove the top flap, and tape the side flaps together. When a child stands in front of the box, they can place their paper inside the box and they won't have to crunch to see inside.

THE PROCESS

Guide children in drawing the lobster. Starting above the halfway point of the paper, draw a short, horizontal line for the head with a black oil pastel. Below the line, draw the letter *U* to connect the line to form the head. Add two circles for the eyes. Draw an upside-down letter *U* on the top of the line. Add a large rectangle with rounded corners for the main body followed by four rectangles that get progressively smaller. This is called the abdomen, but it looks like the tail. At the tip of the tail add five round shapes for the tail fan.

The claws are the fun part and really identify the pile of shapes as a lobster. There are two claws: the pincer and the crusher. The pincer is the larger of the two and points up toward the top of the paper. The claws are attached to the body by two sets of knuckles that look like irregular-shaped squares. The four walking legs are located on both sides of the body.

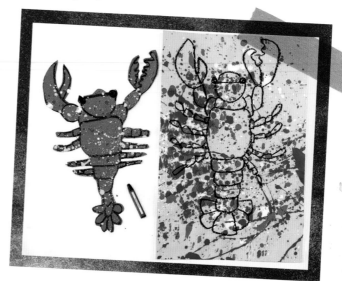

They each have four sections, but that's a lot of shapes to draw. Keep it simple and add three sections to each leg: a medium-length rectangle followed by a short rectangle followed by a longer rectangle.

After drawing the lobster, take the drawing to the splatter box. Use whatever paint colors look good with your paper. It's not necessary to use red paint. Lime green or purple works, too.

Place the lobster drawing face up inside the splatter box. Dip a large paintbrush into a tub of liquid tempera paint. Remember, it's easiest if the paint is the consistency of heavy cream. Hold the brush over the lobster about 3" to 4" away. Tap the brush onto an outstretched finger hovering over the drawing. Move the drawing around so the splatters aren't concentrated in one area.

After the paint dries, cut the lobster out and glue it to a colored piece of paper. I use school glue, but if you have rubber cement, that works better as you can reposition the lobster if needed. Now it is time to use the black oil pastel to go over any lines covered with too much paint. Draw two long lines for the antennae. They are long and can reach below the tail.

Some children may want to add a platter to the background paper. If that's the case, draw the platter before gluing the lobster onto the paper. Draw a large oval with an oil pastel. Color or paint designs on the rim of the platter. Glue the lobster to the platter.

Chapter Six

INSPIRED BY NATURE

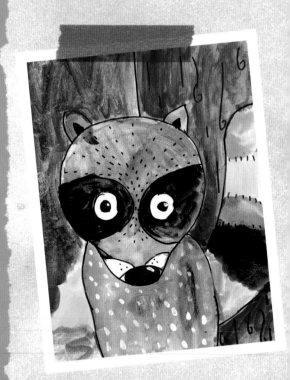

I often look to nature when I need inspiration for a project for one of my classes. I'm fortunate to live near the California coastline and see whale spouts, seals, raptures, herons, and pelicans on a regular basis. When I share my stories with my students, they are reminded of when they saw their first whale or a seal pup on the beach.

This section of the book introduces drawing and painting projects that offer a variety of choices for both new and experienced artists.

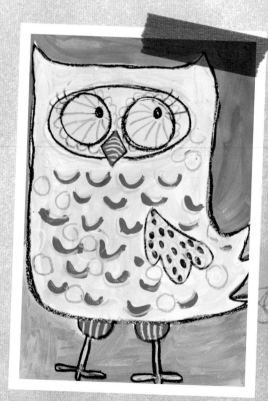

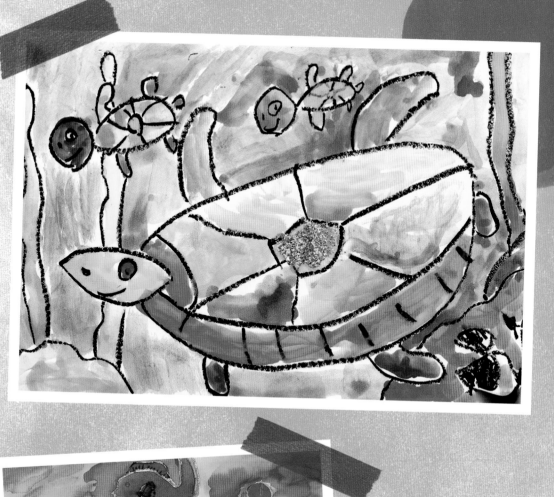

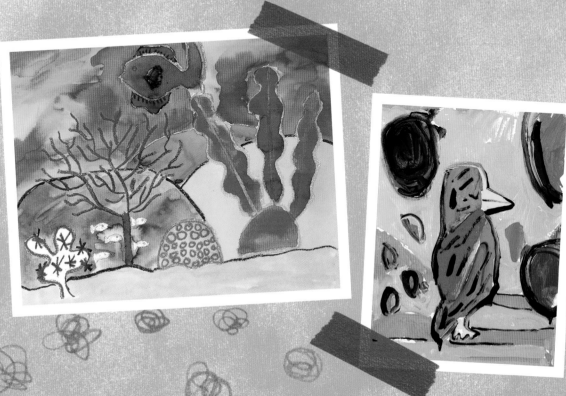

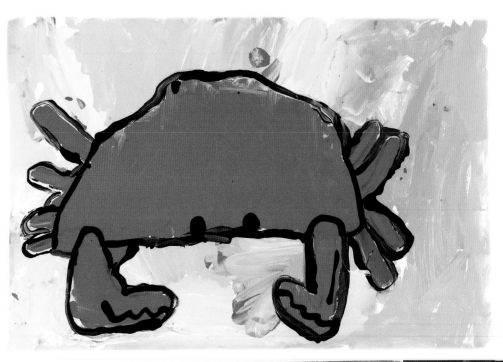
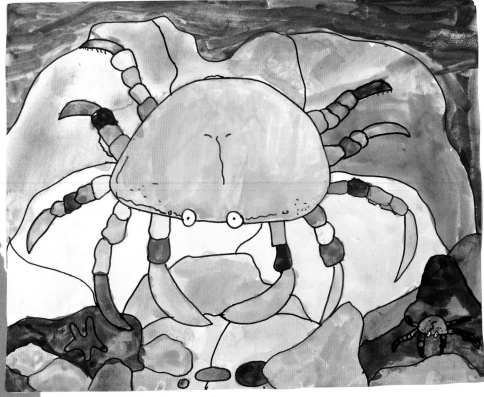

RED CRAB AND COASTAL CRAB

This is a great lesson to use if you're creating art with children of various ages. The red crab project allows a young child to create art alongside older siblings, who can create a detailed coastal crab with the use of a waterproof black marker, watercolor paints, and water-color paper.

red crab

Sometimes a drawing is just a starting point for paint. This cute crab is a perfect beginning lesson for little ones learning to paint. The drawing steps are simple and will allow a child to paint to her heart's content without worrying about painting over the lines.

what you'll need

- 1 sheet of 12" x 18" white drawing paper per child
- Blue, white, black, orange, and red liquid tempera paints
- Black oil pastel or crayon
- Medium and small brushes

what you'll learn

- How to draw a simple crab

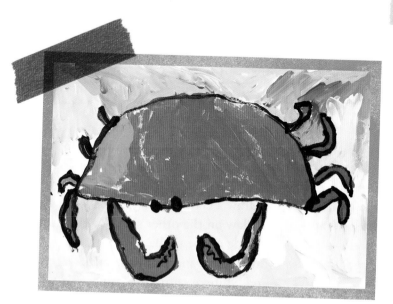

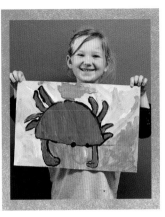

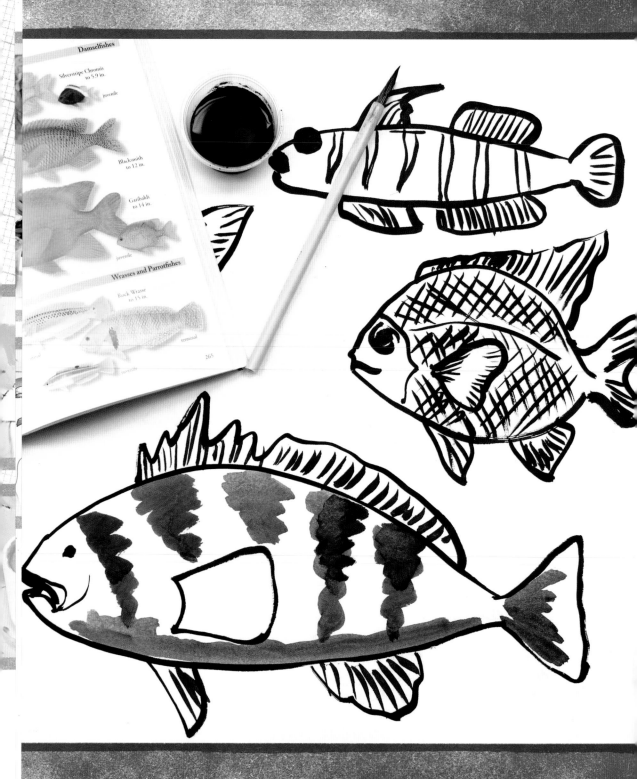

EXPRESSIVE BLACK-AND-WHITE FISH

I often encouraged my students to outline their artwork with black lines. Most often, the black lines are from an oil pastel, but it can also be black tempera paint and a small brush. One time, a fellow art teacher recommended I try a sumi-e brush and ink. I was intrigued but never placed these two items on my art supply list until now. Oh, what fun I missed.

Painting with black ink is an experience in itself, but painting with a sumi-e brush amps up the expressive quality of this art medium. There are very specific ways in which to paint with a sumi-e brush, but instead of focusing on the proper use, I decided to approach the medium with a sense of curiosity.

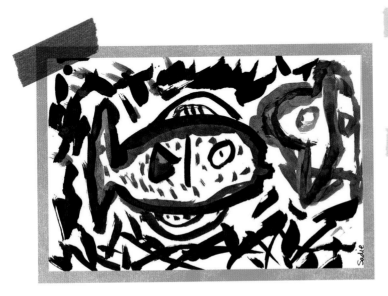

what you'll need

- 1 large sheet of 18" x 24" white drawing paper
- Sumi-e brush
- Sumi-e black ink

what you'll learn

- How to paint using texture as a guide
- How to draw from observation

THE SETUP

To start, use large 18" x 24" sheets of white paper. One little guy used a 12" x 18" sheet because the large sheet was just too big. Place a small amount of ink (1 tablespoon) in a small flat bowl. Add a small amount of water. Make sure the dish is stable and won't tip over or you'll have a mess. Offer each child a sumi-e brush.

THE PROCESS

To get used to the brush and see what lines the brush produces, dip the brush into the ink and allow the ink to soak in. Place the brush at the top of the left hand side of the paper and draw a line down to the bottom of the paper. Notice the thickness of the line. Without adding anymore ink, notice the shape of the brush. Is it straight? Curved? Try placing the brush on the paper to see what markings result. Draw another line, this time pressing harder. Is the line thick or thin? Is the ink dark or light? Continue to experiment this way to get a feel for the brush. Because the brush is so soft children will be tempted to treat it like an all-purpose brush. The intention is to work with the brush and create lines given what state the brush is in.

After experimenting with the brush, dip it into ink again. With the variety of detailing found in fish, the sumi-e brush techniques can be very effective. Set out a few books to offer ideas for different types of fish. Study the shape of various bodies and fins, noting the contour or outside shape, the details of the fins and tails, and any patterns inside the body.

With the brush dipped in ink, draw the body first and then add a tail. Next draw the fins. Experiment painting patterns with various textures: dark and light, thick and thin, curly and straight. The results are strong and expressive. The best part about this project is that it is based on the process and less on the final outcome.

ABOUT SUMI-E

Sumi-e is the Japanese word for painting with black ink. Sumi-e artists appreciate the beauty and unique qualities of each stroke. When using sumi-e ink, make sure to devote a special brush meant just for this type of ink, as this ink can never be fully cleaned.

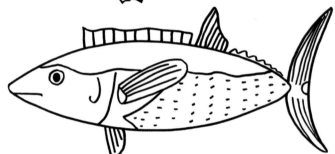

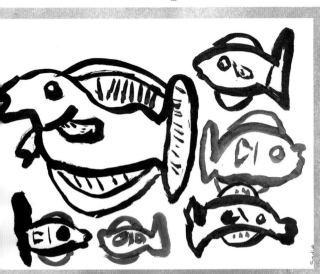

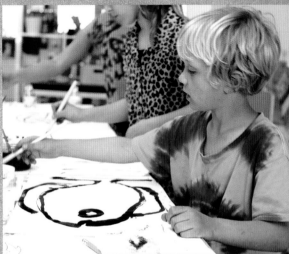

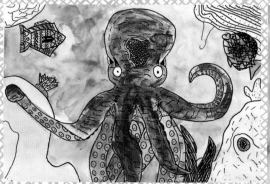
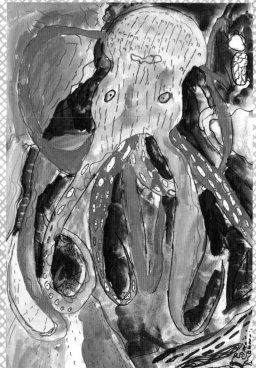
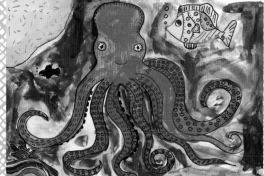
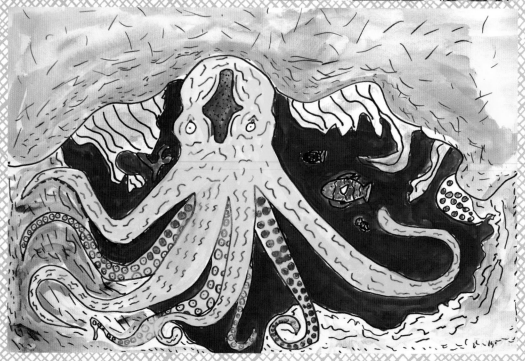

OCTOPUS LINE DRAWING

Creating art in a small group setting offers children a chance to see how everyone draws differently despite using the same subject. Each artist comes up with unique shapes, lines, and color combinations. What I like most about drawing this cave-dwelling octopus is how loose a child begins to draw once a pencil is removed from their hands.

THE SETUP

Drawing with pencils compared to drawing directly with a black marker can be less scary. In art class, I would begin many detailed drawing lessons without pencils. The idea is that once children get used to drawing with markers, they become fearless with their art.

But since it can take some time for children to build their confidence, begin with a pencil. Draw the general outline and as soon as the octopus shape forms, replace the pencil with a marker. This makes for a more expressive and detailed piece of art.

THE PROCESS

Start the drawing with a pencil on a sheet of watercolor paper. Draw two dots in the upper middle of the watercolor paper for the pupils and added a circle around the dot. Two curved lines beside each eye socket and a bulb-like shape above the eyes form the beginnings of the head.

what you'll need

- 1 sheet of 12" x 18" watercolor paper per child
- Tray of watercolor paints
- Pencil
- Black waterproof marker

what you'll learn

- How to draw through observation
- How to draw to show perspective and form
- How to add texture with stippling and cross-hatching

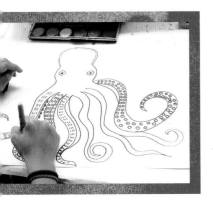

Guide children in drawing the octopus arms. To draw the arms, it's easier to divide the eight arms in two sections: four front and four back. The four front arms are drawn first and should take up as much space on the paper as the artist wants. After drawing the front arms, draw the four back arms. Once all of the arms have been drawn, trace over the pencil lines with a black waterproof marker.

Drawing the small, repetitive details like the cross-hatching and suction cups proceeds much faster with a marker. An artist who draws a line by mistake can turn it into another detail or pattern. One boy decided he didn't like his octopus's head, but after adding the cross-hatching, he found that the line he didn't like melted away under the contrast of details.

To draw the background, imagine the octopus hiding in an underwater cave. Draw rocks on the top of the paper, around the sides, and even on the bottom. Draw small rocks closest to the bottom and add rocks behind these. Draw the lines with a combination of both rough and smooth. Variety is key. Younger kids will almost always draw smooth rocks, but the older they get (8+), the more interesting the shapes will be. The rocks continue on the sides as well as the top. For extra details, consider adding coral and seaweed to the rocks and even a few fish swimming by.

Depending on the brand, your watercolor paints might be more opaque or translucent. The Faber-Castell watercolor paints that we used for this project were opaque watercolors, meaning that the paint will be less see-through than typical watercolor paints. If you have opaque watercolor paints, show the kids how to keep their brush wet so that the paint doesn't get too muddy or thick.

Select two colors for the octopus. Consider in advance what color the water will be and make sure the octopus is a different color. The best strategy is to find two colors that are beside each other in the watercolor trays and use a combination of these colors to paint the octopus.

Paint the lightest of the two colors over the entire octopus. Add the darker color to the outside edges and back arms to create darker shadows and depth. Paint the ocean one single color. Use lots of water to vary the intensity.

Choose one color plus black for the rocks. A word of caution about black: use a light touch as black is a powerful color. To make a shade, swirl the brush into a color then add a touch of black paint. Good suggestions are yellow and black, orange and black, brown and black, or even green and black. Vary the intensity (lightness or darkness) of the color by adding more color or more water. Finish painting the seaweed, fish, or any other sea life in the art.

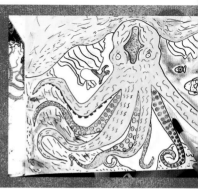

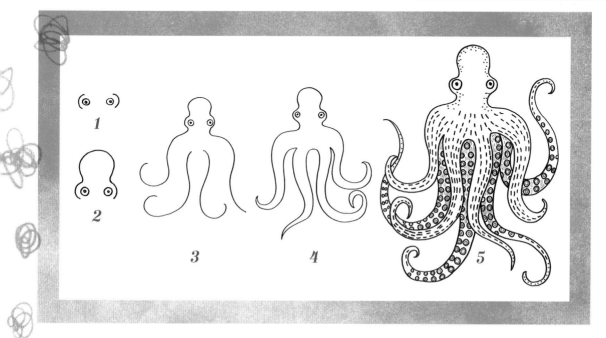

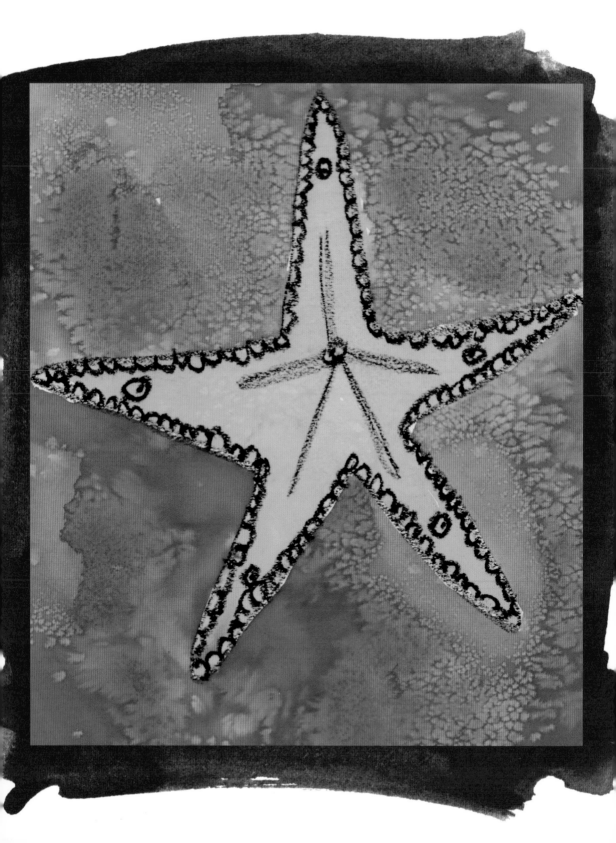

STARFISH

Starfish, or sea stars, come in many shapes, sizes, and even colors. During low tide on many seaside sandbars, sea stars are visible in the shallow pools and clinging to rocks. In my hometown province of Prince Edward Island, sandbars are littered with light purple sea stars—not a color you would imagine. Drawing starfish is always a favorite of my students and using watery paints makes the experience even better.

THE SETUP

This project uses a 12" x 9" piece of watercolor paper, oil pastels, table salt, and liquid or tray watercolor paints. In order for the salting technique to work, you must use watercolor paper. Regular paper soaks up the paint, which prevents the salt from absorbing the liquid color.

what you'll need

- 1 sheet of 12" x 9" watercolor paper per child
- Liquid or tray watercolor paints
- Oil pastel
- Table salt

what you'll learn

- How to draw a starfish
- How to create texture with salt
- Wet-on-wet painting technique

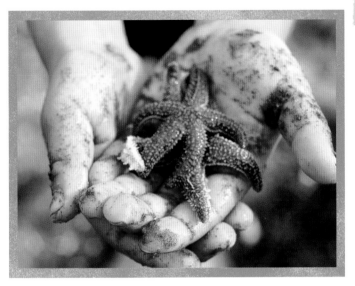

THE PROCESS

Start drawing your starfish or sea star in the center of the paper. With a very light touch, use a black oil pastel to draw a small circle about the size of a golf ball. From the circle, send out five very light lines in all directions. The lines will become the arms. Draw a dot between each line about ½" from the circle. Connect the dots and the end of the lines all the way around the starfish. Use a white oil pastel to add dots or textured lines around the center and arms of the starfish.

Use liquid watercolors or tray watercolors to paint the sea star. Younger children will want to paint their beautiful drawing with as many colors as they see. To avoid the muddy effect you get from mixing complementary colors (colors opposite of each other on the color wheel) stick with two or three color choices. Keep in mind the best color choices for blending are colors that are beside each other on the color wheel or in the watercolor tray. Try red and orange, pink and violet, or green and turquoise.

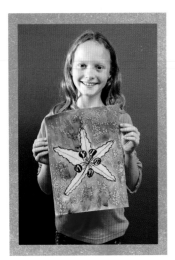

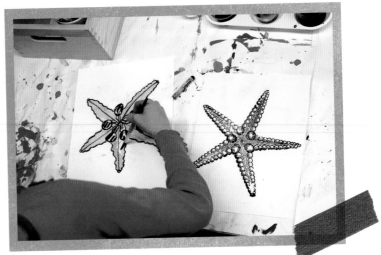

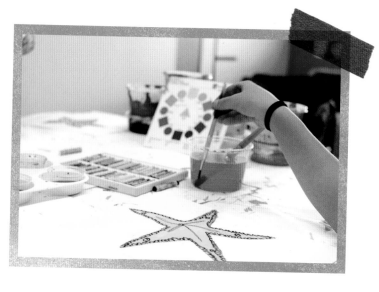

After painting the sea star, dip a clean brush in water and use it to paint the entire background. Before the water dries, dip the brush into an ocean color and spread it over the wet paper. This technique is called wet-on-wet. You'll notice there are less brush marks when the paper surface is wet compared to when you paint on a dry surface. While the paint is wet, sprinkle table salt over the surface of the background color. As the paint dries, the salt will pull the color and leave a starburst effect. Make sure you are using watercolor paints, not tempera paint, as the paint needs to be transparent in order for the salt effect to work well. It's equally as important to be using watercolor paper, as the paint needs to sit on top of the paper rather than sink in to achieve the effect.

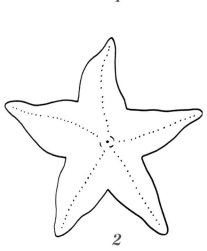

1

2

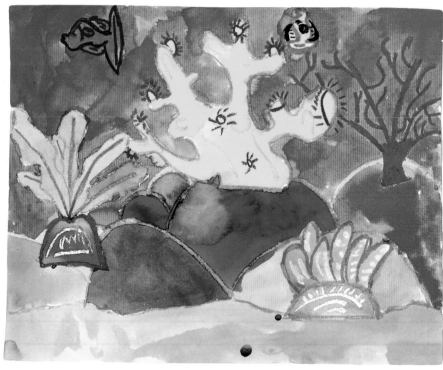

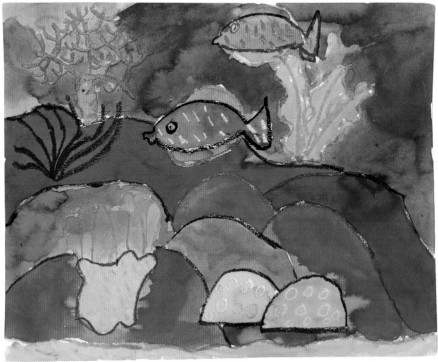

CORAL REEF

Coral reefs are diverse underwater ecosystems built by secretions from corals. The colors, textures, and animal life are abundant. Drawing an undersea world requires a bit of thought. If you ask a child to draw a fish under the sea, they will typically draw an ocean floor with a single plant or two rising from the bottom edge of the page. Coral reefs feature stacks of rocks, plant life, and corals. This project shows children how to create the illusion of depth by stacking objects.

THE SETUP

You'll need oil pastels or very waxy crayons, water-color paper, and tray or liquid watercolor paints to create a colorful coral reef. It helps to have plenty of resource materials available for fish, coral, and other undersea life.

what you'll need

- 1 sheet of 12" x 18" water-color paper per child
- Tray or liquid watercolor paints
- Oil pastels or waxy crayons

what you'll learn

- How to create the illusion of depth in a drawing
- Wet-on-dry painting technique

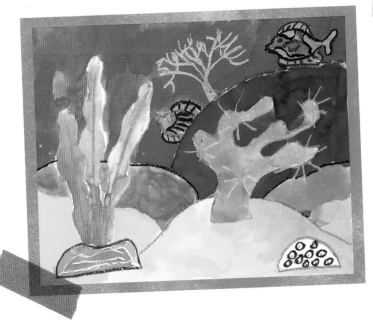

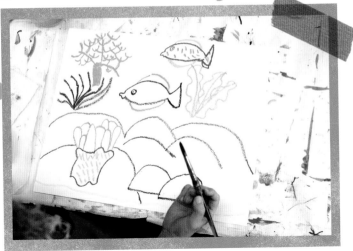

THE PROCESS

The trick to drawing the reef is to draw a single plant close to the bottom of the page but not touching the bottom. Because this plant is near the bottom, it is also closest to the viewer. Draw it so the top of the plant reaches at least halfway up the paper. Next, draw the ocean floor line from one side to the other, hopping over the plant and making sure the line allows for space both above and below the line.

Below the ocean floor line, draw a few curved rocks. To add the next layer, draw another rock by drawing a curved line starting on one side of the paper toward the middle of the page. The rock should end at the ocean floor line. Start to add more layers of sand or rock behind the front plants or drawings. Older children will notice the opportunity to add more coral, plant life, and smaller rocks growing from the larger rocks. Keep adding the layers.

Use an oil pastel or waxy crayon to add patterns and lines inside the shapes. You may have to remind younger children not to color in the shape with crayons. Finally, add a few fish in the water above the reef.

Use tray watercolor paints for the most color opportunities. Dip a paintbrush in water and swirl it

around the outer rim of the watercolor cake. To paint effectively, trace around the outside of a shape slowly, then paint a little faster on the inside. This works if the shape is not too big. Paint the rocks, seaweed, corals, and fish with as many colors as you choose. If the paint dries completely, use a very small brush to add details like stripes, spots, or patterns to their shapes. This painting technique is called wet-on-dry.

If you have a large blank area of paper for the ocean, draw a few more fish so the area is not as sparse. Use the wet-on-wet technique for the ocean color. Simply wet the paper with a brush dipped in water. Then, add paint to the brush and paint over the damp paper with smooth strokes. If the paper is really wet, tilt the paper to allow for the movement of colors.

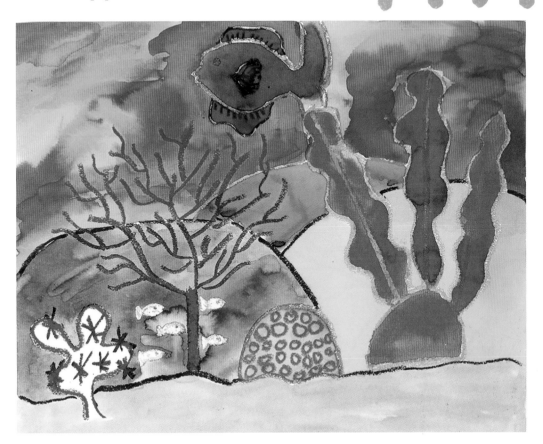

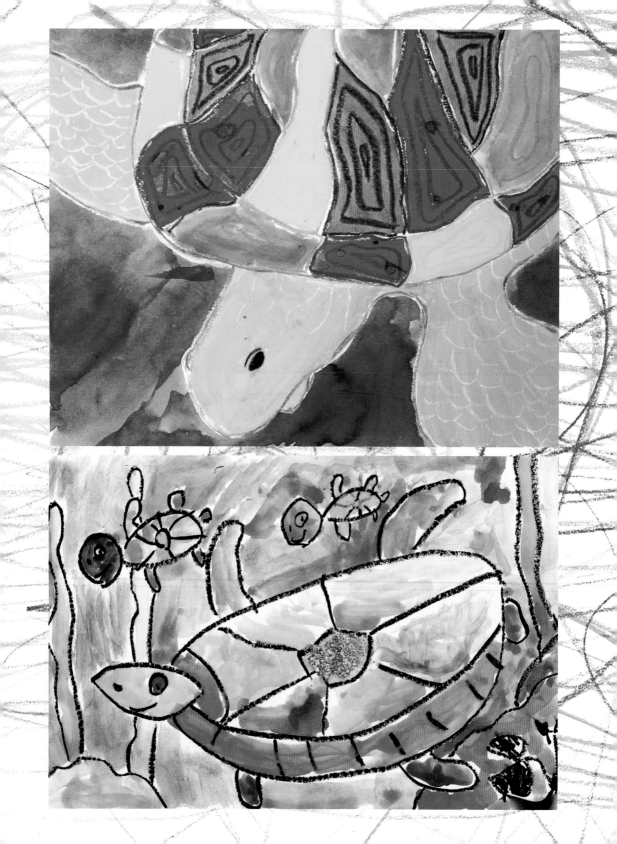

SEA TURTLES

Drawing sea turtles is a popular subject for all kids. The familiar shape paired with the beauty of the ocean allows for many wonderful art adaptations. You can draw turtles so their entire bodies fit inside the paper or the turtle can be so large that it falls off the page. This enlarged turtle focuses on the details of the shell. Younger children will find it easier to draw the entire turtle body inside the paper.

THE SETUP

While you can use any medium you like, I selected watercolor paint as it felt natural to use these beautiful colors for these beautiful creatures. Feel free to substitute cake tempera paints or even acrylic paints with regular drawing paper for this project.

what you'll need

- 1 sheet of 12" x 18" watercolor paper per child
- Watercolor paints
- Colored oil pastels or waxy crayons
- Medium brush

what you'll learn

- How to draw an oversized turtle
- How to draw both a simple turtle and detailed turtle for all ages

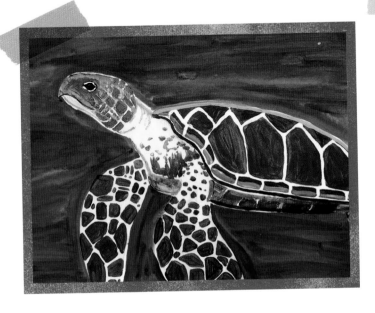

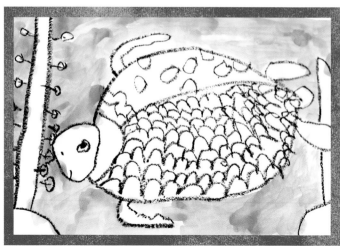

THE PROCESS

Use the simple drawing steps to guide children in drawing the turtle. With an oil pastel or crayon, draw the turtle's head. It is shaped like a walnut. I like to draw a rather bumpy sideways letter *U* and then connect the bottom lines with a slightly curved line. From there, we draw the neck. To draw the large shell, place the pastel on the top part of the neck and draw a large curved line. If the line goes off the edge of the paper, keep drawing until you get back on the paper again. This is a great way to draw an enlarged or oversized object. Of course, make sure to have a paper placemat or newspaper under your artwork.

Draw the bottom shell. Many shells have a ribbing or banding around the outside edge. You can draw this if it suits your turtle. Add two front legs. The front legs are the swimmer legs and are much larger than the back legs. It's possible that only one leg will fit depending on how large your turtle is. Draw the smaller back legs.

Loggerhead and green turtles have a specific honeycomb pattern. Draw four short horizontal lines inside the shell. Between each line and on both sides of the line, add dots. Connect the dots with the ends of the lines to form the pattern.

To begin painting the turtle, pick an ocean color that is different from the turtle so the turtle will stand out. It doesn't matter what you paint first, but most children will start with the turtle. Some kids use many colors, while others create a more subdued palette. Use the techniques described in the coral reef project (page 111) to paint both the background and the turtle.

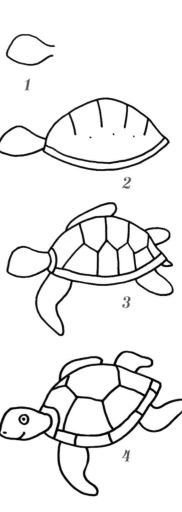

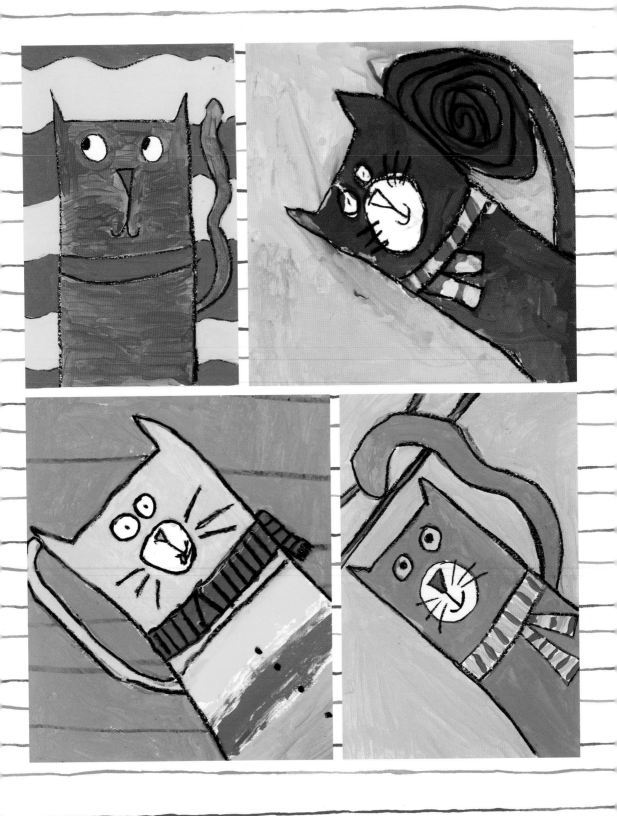

FUNKY CAT

If you're having a hard time selecting a project to do first, this project is a winner for all skill levels. Just a few simple lines create a cat that can be personalized with an array of patterns and details.

THE SETUP

To encourage a large cat, use a black oil pastel and 12" x 18" paper. The drawing steps are so simple that most kids can replicate the cat quickly and easily just by looking at the picture. Still, if you have children younger than 6, it is helpful to fold the tall paper in half horizontally, and use the crease as a guideline.

You can use most any type of paint for this project. I used liquid tempera paints. The paint should be thick enough to barely see the pastel lines under the paint. Depending on the brand of paints you buy (some tempera paints are very thin), you may need to use two layers of paint or choose acrylic paints instead.

THE PROCESS

Guide children in drawing the cat. Add two circles in the top half of the paper, or above the crease line, three to four fingers apart. Add two pupils by coloring a dot with the pastels inside the circles. Finish the face by drawing an upside-down triangle nose—kids can decide if the triangle is long or wide—then add a line for a mouth. Draw a horizontal line above the eyes, stopping just past the outside of the circles. For the ears, draw an angled line toward the corner of the paper (but not too long) and then draw a straight line down and off the bottom of the paper. Hold off drawing the whiskers for now.

what you'll need

- 1 sheet of 12" x 18" white drawing paper per child
- Liquid tempera paints in a variety of colors
- Colored oil pastels including black
- Medium brush

what you'll learn

- How to connect lines and shapes to form a simple cat
- How to use the "smoothing" painting technique

This is the fun part: add a bow tie, bow, collar, choker, or any detail you like. Leave this up for the kids to decide. Keep the shapes simple. If the child wants, they can draw large polka dots or stripes in the background.

Now it's time for the paint. I challenge my students to select two colors for the cat and one main color for the background. If kids are having a hard time choosing a color, I always bring out a mini color wheel to show them how colors work together. They can choose colors that are beside each other on the color wheel (analogous) or even opposite each other (complementary). Small kids may have a hard time limiting their color choices and that's fine. Perhaps present two or three options and allow them to narrow down a section that way.

Once you've chosen a color, paint the cat with the main colors. For the collar, background patterns, and even the nose, allow the child to select any color. Once the paint has dried, trace over the oil pastel lines again to make the colors really pop. Draw the whiskers with the oil pastel over the dry paint.

tip

After you paint the background, you may notice lots of uneven areas of paint. To smooth the paint, brush over the paint surface again with a dry brush. I call this "smoothing" the paint. This helps spread the wet blobs of paint over the thinner areas.

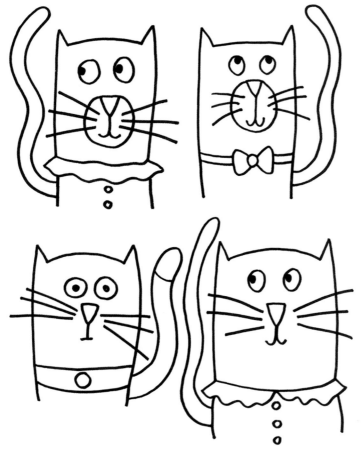

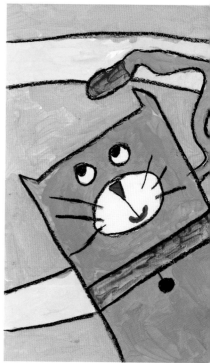

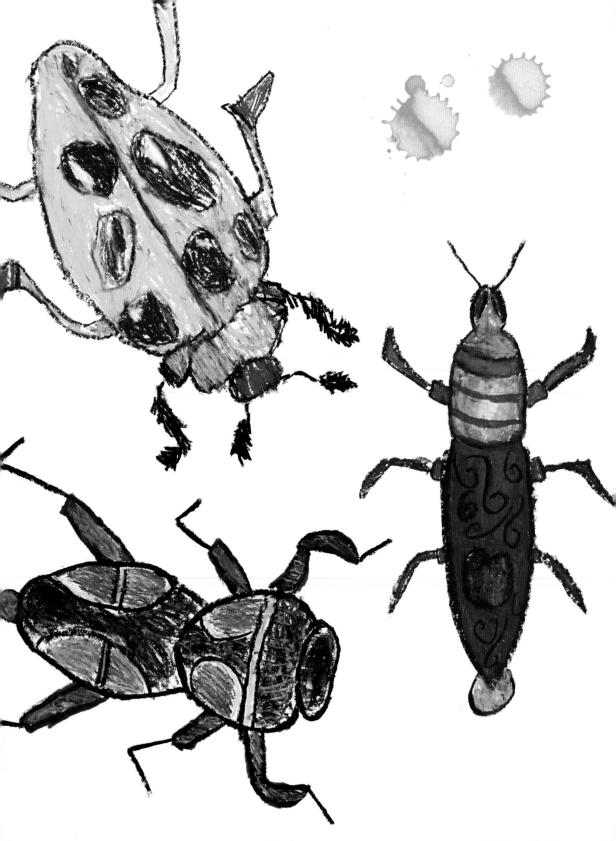

SYMMETRICAL BEETLES

Drawing bugs, beetles, and other insects is a great way to introduce the concept that drawing is as easy as connecting a series of lines and shapes. Beetles are particularly interesting because they are symmetrical. Teaching a symmetrical drawing in a school setting is always popular as the teacher can introduce vocabulary and math concepts.

Drawing beetles also offers children the chance to observe the beauty and wonder of nature. It is very helpful for kids to have visual guides of beetles through picture books or websites as it's hard to explain how beautiful beetles really are.

THE SETUP

Drawing the beetle with an oil pastel or black waterproof marker preps the art for a wide choice of coloring skills. Coloring with oil pastels is great for older kids (8+), as coloring requires more effort and patience than painting. For younger kids, using cake tempera paints or opaque watercolor paints allows a child to add color in a quick way. It's also fun to cut the beetle from the white paper and glue it to a colored paper. If you aren't in the mood for paint, use broad-tip markers to draw and color the beetle.

what you'll need

- 1 sheet of 12" x 18" white drawing paper per child
- Colored oil pastels including white and black
- Optional: Cake tempera paints and black waterproof marker

what you'll learn

- How to draw a symmetrical object
- How to blend oil pastels

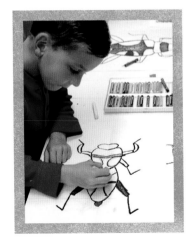

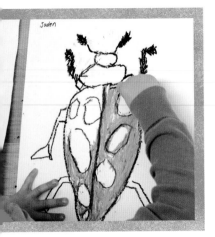

THE PROCESS

Start with a large sheet of white paper and an oil pastel or black marker. Guide children in drawing the beetle. Since the kids won't be able to erase their lines, you must create an environment in which they feel free to make mistakes. The best way to demonstrate this attitude is by purposely making a few "mistakes" yourself when you create art.

I like to begin with the eyes. Draw two circles near the top of the paper. Then, draw a connecting line (wavy, straight, or curved) between the two eyes. Draw an oval or a rectangle with rounded corners below the eyes and connect them with two small lines. A vertical line divides the beetle/bug/insect in half lengthwise. A short line creates a small bug, but a longer line creates a long bug. Add the "sides" of the body. Add jointed legs, keeping care to make each side of the beetle symmetrical.

Encourage kids to draw just one insect per paper. This will be hard for some kids, so if they object, don't make it into a big deal.

Many kids will spend a lot of time working on the head and body so by the time they get around to making the legs they give up a bit and draw rather spindly things. Be prepared for this by interrupting them and offering a demonstration geared to legs. Ask questions. Look at how many segments are in each leg. What shape are they? Where do they bend?

When using oil pastels to color in the beetle, teach children how to trace around and over the black oil pastel line to smudge the line. Then, color in the middle of the shape. The black oil pastel creates a shadow effect when smudged. If a child does not like this effect, painting with cake tempera might be a better coloring choice.

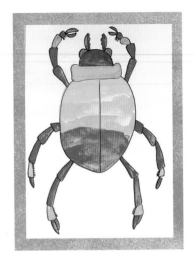

As an art teacher, I look for as many drawing opportunities as possible to introduce children to symmetry. Nature is a great resource as many insects, butterflies, and leaves all support beautiful demonstrations of symmetry.

One way to create a symmetrical drawing is by observation or free-drawing. This is what we do in the beetle project and the Jackson Pollock-inspired lobster project (page 87). Here's another method you can try that is part drawing and part magic. Fold a sheet of 12" x 18" paper in half like a book. Open the paper up. On one side of the fold, draw half a beetle or half a butterfly with a black oil pastel. Fold the paper in half, sandwiching the drawing on the inside. Rub the folded paper over and over again. Use friction to warm the paper and "melt" the oil pastel. When you open up the paper, you'll see that the oil pastel has transferred to the other side. Trace over the light transfer lines and you have a perfectly symmetrical drawing!

MANAGING SMALL MISTAKES

If the head you draw is too small, draw a large head around it and mask the mistake with lines and patterns. If you make the eyes smaller than you like, don't worry. Draw another shape around the eyes and now the original eyes can act as the pupils. You get the idea. The insects do not have to be realistic, but rather filled with pattern and color. This way, the opportunities are endless for fixing "mistakes."

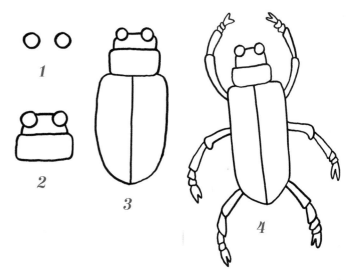

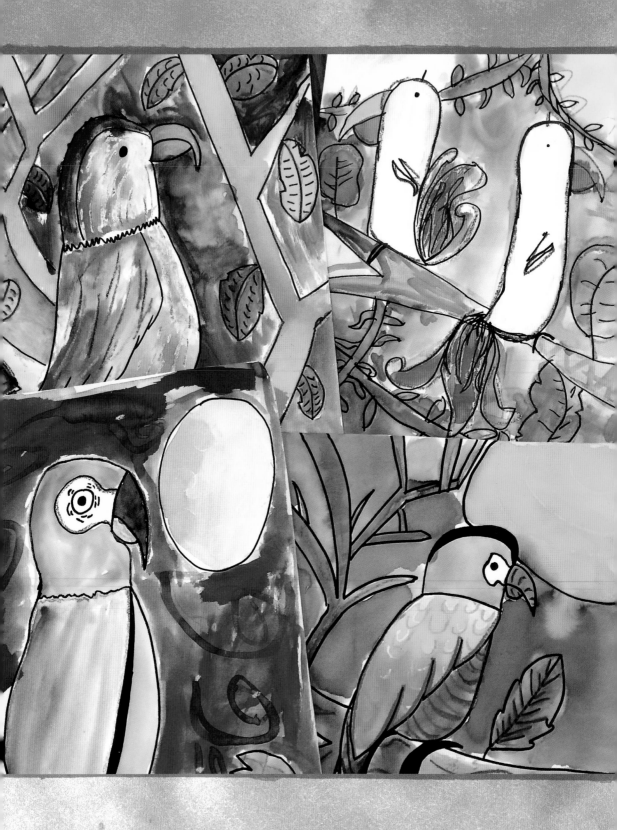

PAINTED PARROTS

I taught a bird-drawing lesson every year I was a teacher. There is something very familiar about drawing a bird as most kids can draw one from memory. It's a great opportunity to have fun with a common subject. For my little ones, drawing parrots with curly head feathers or rainbow-colored tails creates a new level of energy in the art. This project teaches children how to draw a tropical bird and offers two painting options: using watercolor on watercolor paper or acrylic paints on sheet canvas.

Watercolor allows the child's intricate drawing to be the focus, while using acrylic paints allows for a more expressive quality to the painting. Some children prefer the transparency of watercolor as the paint won't cover up any of the drawing lines. When using acrylics, on the other hand, most drawing lines will be completely covered by the thick paint. This allows for a lot of fun mixing colors and layering texture. Try both to see which one your child prefers.

THE SETUP

Select which art medium option you would like to try, then prep your workspace accordingly:

Option 1. Draw with colored oil pastels on water-color paper and paint with watercolor paints (ages 6+)

Option 2. Draw with a pencil on sheet canvas and paint with acrylic craft paints (for ages 5+) or artist-quality acrylic paints (8+)

While I love acrylic paints for their thickness and texture, it's not always the most kid-friendly medium. Artist-quality acrylic paints can be expensive and they don't wash out of clothes, so in a classroom setting

what you'll need for watercolor painting

- 1 sheet of 12" x 18" white drawing paper per child
- Colored oil pastels including white and black
- Watercolor paints
- Medium brush
- Water and paper towels

what you'll need for acrylic painting

- 1 sheet of canvas paper (8" x 10" or larger) per child
- Acrylic craft paints or artist-quality acrylics
- Pencil
- Medium and small all-purpose brushes
- Paper towels

what you'll learn

- How to draw a parrot using both guided and observational drawing techniques
- How to overlap shapes
- Wet-on-wet and wet-on-dry watercolor technique
- How acrylic paints differ from watercolor paints

they aren't the best choice. For a home or small-group environment, they work beautifully. Acrylic craft paints that you can find in craft stores are less expensive. They come in very small bottles and a variety of premixed colors. I find these paints very similar to tempera in that they are very kid-friendly. With both styles of acrylics make sure to use a sheet of waxed paper, a paper plate, or even a sheet ripped from a magazine as your palette. After the project, throw the plate or paper in the trash. Washing acrylic paints down the drain can clog your sink. Trust me on this one.

THE PROCESS

Guide children in drawing the bird. Whether drawing with oil pastels or a pencil, start with a dot for the eye near the top of the paper but not too close to the top edge. Add a line in front of the eye. The line can be straight or curved depending on how you want the beak to look. Draw a perpendicular line extending from the vertical line. Make this line as long as you want your beak to be. Draw a circle around the dot. Place the oil pastel at the top part of the beak and draw a line around the top of the head and around the back. Draw a small line for the front of the neck. Add a bumpy line for the neck ruffles. This line helps separate the head from the body.

Because the wing overlaps the body, you should draw it first. Place the oil pastel on the bottom of the head and draw a slightly curved line down as far as you want the wing to be long. Then, move back up to the neck and draw the inside of the wing shape. Wavy, scalloped, or feathered—it's up to you!

For the body, decide how big or small the bird will be. I often ask little ones how many worms their bird ate. If they ate a lot, draw the body with a big belly. This simple question reminds the kids of what they are drawing. Add two small bumps to indicate where the

legs will extend. Draw the legs angled toward the front of the bird instead of straight down. Draw the feet/ talons next and then make a branch if you want the bird to be perched on something. Add a long or short tail depending on your bird selection. Most of the time—if the child has drawn large shapes—there won't be much space left for the tail. Don't be afraid to extend the tail right off the bottom of the paper.

If they are drawing with a pencil, encourage kids to draw as big as they can. This is important for younger children (ages 6 to 8) as they will naturally draw small with a pencil. Smaller shapes are difficult to paint with acrylic paint, as it is very thick. Instead, when drawing the bird, use phrases like "draw the head the size of a golf ball and draw the bird's body as big as your hand." This gives the child perspective and helps create a larger drawing.

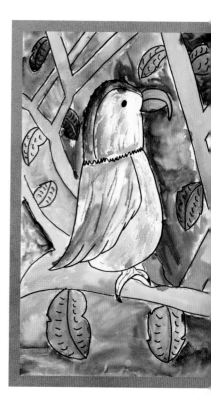

tip

If you are using a good sheet of canvas and are a bit nervous about messing it up, don't be. Whatever mistakes the kids make will add to the art. Still, sometimes it's fun to practice the drawing steps together on a piece of regular drawing paper to get the feel for the steps.

tip

To challenge older kids (10+) have them draw their bird with a waterproof marker, like a Sharpie, or even a pencil on the watercolor paper. Since the marker won't control the watercolor paints, the painting must be done carefully in order for the paints not to bleed into each other. This is a technique I do with older kids as they have the appropriate skills. Yet drawing the bird with a black waterproof marker and painting freely with liquid watercolor paints is quite fun for little ones. Just don't expect them to stay within the lines!

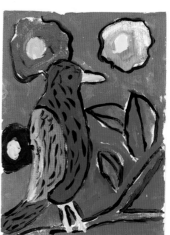

watercolor painting

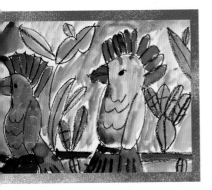

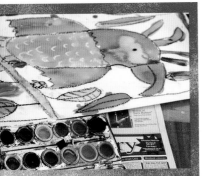

After the drawing is finished, set out trays of watercolor paints, water containers, and paper towels for dabbing brushes. Painting on watercolor paper when oil pastel is used for the drawing is relatively fast. The oil pastel acts like a wall, preventing the paints from bleeding into each other. This is not always the desired result, but it sure helps keep colors contained.

If you want to introduce some cool watercolor techniques, try these:

1. Wax resist: With a white oil pastel, draw patterns, feathers, dots, or dashes before painting. Then paint over the white oil pastel and see the patterns emerge.

2. Wet-on-dry: Paint a base layer of any color on any part of the parrot or background. When that area dries completely, dip a small paintbrush into a dark color of paint and draw details like feathers, leaf veins, or ribbing on talons. The wet paint allows a child to draw details without using pastels.

acrylic painting

Make sure that each child has lots of white paint on their palette. If the colors of the acrylic paints appear too intense, you can mix them with white paint to lighten. (This is different from how you would lighten watercolor paints, which is by adding more water.) Kids love mixing acrylic paints because of the creamy, thick consistency.

Start by selecting one color of paint for the background. Paint carefully around the leaves, branches, parrot, etc. Smooth paint with the brush or allow lots of texture to show. After the background, paint the parrot. Acrylic paints work better when you don't use water to clean the brushes, as it dilutes the consistency of the paint. Instead, provide paper towels so children can clean their brushes.

tip

For small children (6+), I like using a Styrofoam egg carton to separate the acrylic paints. Pour paints in order of lightest to darkest: yellow, orange, red, purple, blue, and green. When children paint, start with the yellow and paint parts of the parrot yellow. Then without cleaning the brush too much, dip into orange and paint any section of the parrot orange. Then wipe the brush on the paper towel. Dip into the red and repeat. The benefit is that if any paint is left over on the brush, the colors will at least blend together well.

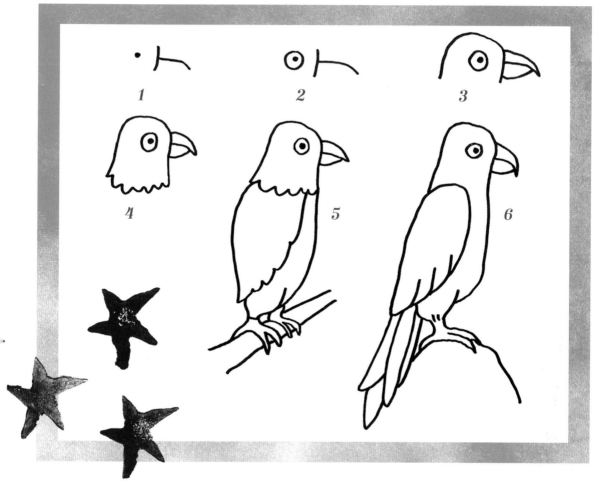

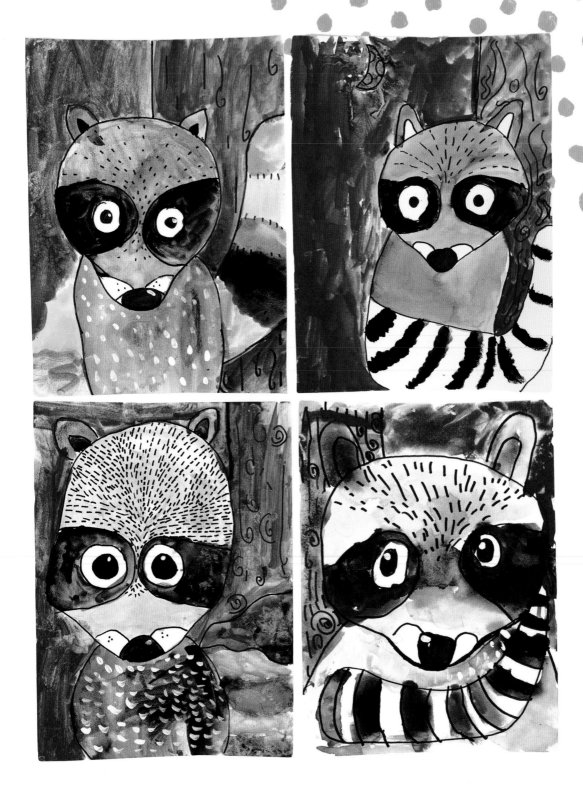

RACCOON AT NIGHT

Raccoons are nocturnal animals who love to eat seeds, bird's eggs, fruits, and, in urban areas, our garbage! Using a palette of just four colors, you'll draw this close-up raccoon with a waterproof black marker and shades of black, blue, brown, and white watercolor paint on watercolor paper.

THE SETUP

For this project, use a smaller sheet of watercolor paper (12" x 9") and a waterproof black marker.

THE PROCESS

Guide children in drawing the raccoon. Start by drawing two dots for the pupils. Place four fingers between the dots to make sure the eyes aren't too close. Make the pupils large by coloring them in with the marker. Add a circle around the pupils. Starting to the left of the eye, draw the sides and top of the head up and around the eyes and over to the other side. Draw an oval shape for the nose below the eyes and below the starting line for the head. Connect the sides to the bottom of the nose with a slightly curved line.

It is important to add a few markings to the face. The first is the mask around the eyes. Place the marker on one side of the face and draw a line that wraps around one eye. Repeat on the other eye. The nose has two lines on either side that remain white. Between the eyes and toward the top of the head, you can add small lines to indicate fur. Add two ears and a tail and finally, a body. Depending on where the child has the most space, place the tail around the front of the raccoon or at the side.

what you'll need

- 1 sheet of 12" x 9" watercolor paper per child
- Black waterproof marker
- Watercolor paints
- Medium brush
- Water and paper towels
- White acrylic paint or white liquid tempera paint

what you'll learn

- How to paint with a limited color palette
- How to paint a night sky

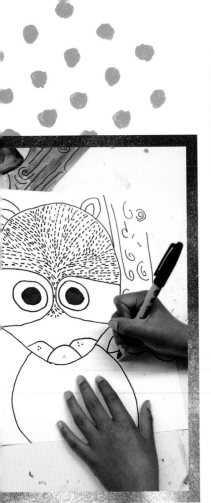

Adding the background details is up to the child. Draw a tree, a moon, the side of a building, or just leave the space empty.

To paint the raccoon, use three colors: black, brown, and blue. Mix a small amount of black paint with a touch of brown to create a smoky gray color. The more water you add to your brush, the lighter the color. It may be helpful to have a small swatch of watercolor paper handy so kids can test their colors. Once the children get used to the various shades black can make, the rest of the raccoon can be as light or as dark as the child wishes.

To paint the night sky, use blue with a touch of black. Paint the tree (if you have one) brown with a touch of black. Leave the moon blank so it remains white. Use white acrylic paint to add small but effective details in the painting. We used a very small brush dipped in white acrylic to add small dashes over the dry watercolor paint to represent the fur. Add a bright white dot in the pupils. This really made the eyes come alive. If a child wishes, they can add stars to the night sky with the back of the brush handle and the white paint.

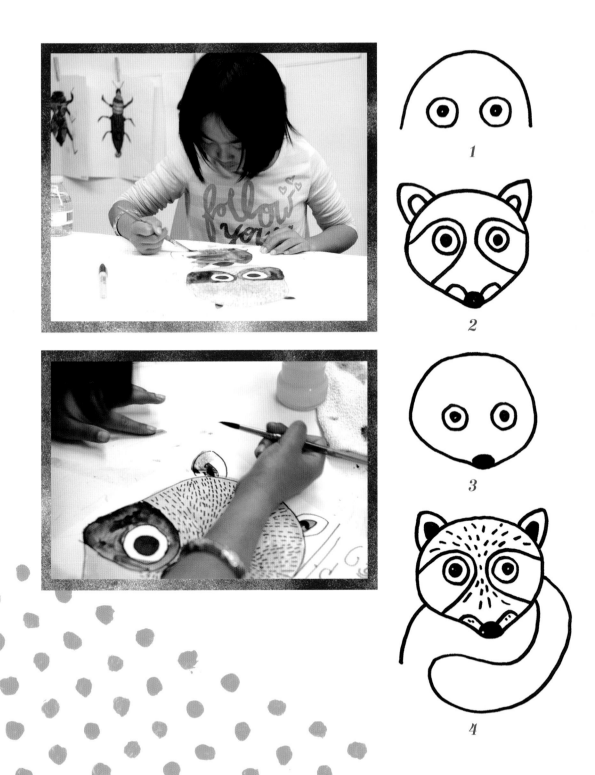

1

2

3

4

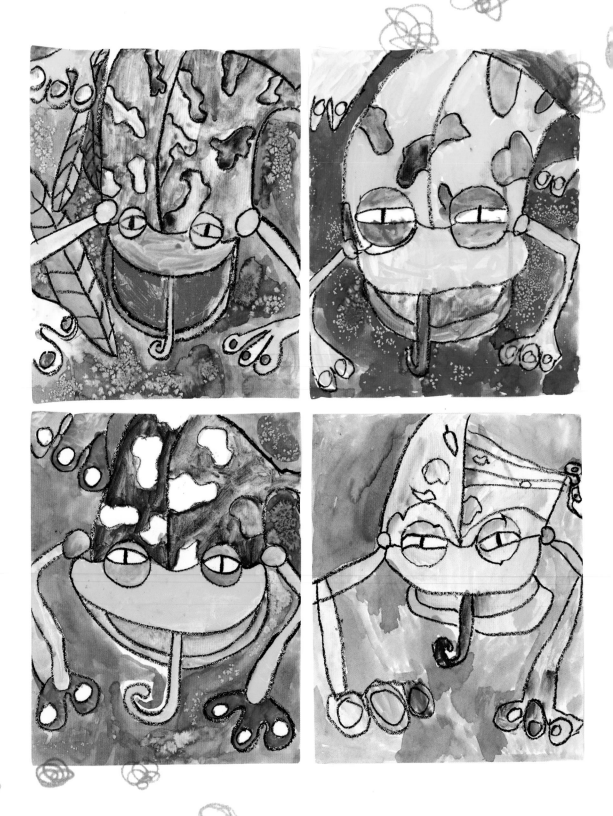

RAINFOREST FROG

Parents and teachers often tell me that they can't get kids to draw big. There are many strategies to help children use the whole paper instead of a small section. We have talked about many of these strategies in this book. This lesson uses the same technique as the sea turtle: drawing off the paper. This allows the artist to draw a large, close-up view of the frog without actually being aware of it.

THE SETUP

Place a 12" x 18" watercolor paper over a paper placemat or newspaper. Pan watercolors are the most common watercolor paints for kids, but liquid watercolors are becoming more popular. Sometimes it's fun using both at the same time. The best time to use the trays is when you want a very specific color that you may not have available in liquid form.

THE PROCESS

Guide children in drawing the frog. With a black oil pastel, draw two circles for the eyes near the vertical center of the paper. For small children (7 and under), use a small plastic condiment cup or a small lid to trace the eye circles. This helps smaller children get a head start on the drawing. Add a rainbow-shaped line and a smile-shaped line inside the circle, making sure the ends of the lines connect on either side of the circle shape. Add a slit for the pupil.

The mouth is divided into top and bottom sections. We'll draw the top first. Starting at the outside edge of the left eye, draw a short line toward the side of the paper. Do the same for the other side. Connect the ends of these lines with a slightly curved line.

what you'll need

- 1 sheet of 12" x 18" watercolor paper
- Black oil pastel
- Watercolor paints
- Medium brush
- Optional: Plastic condiment cup
- Water and paper towels
- Table salt

what you'll learn

- How to draw off the paper to achieve a close-up perspective
- How to create texture with salt

Draw the tongue before drawing the mouth. The kids love being able to make the tongue as long as they wish. After drawing the tongue, draw the bottom of the mouth. It's a simple curved line connecting from one side of the top mouth to the other, but you have to jump over the tongue. You don't want the lines going through the tongue. Draw a line between the eyes to form the top of the head.

To draw a body to match the size of the head, most of the legs and arms will need to extend off of the art paper. Small children will naturally try to fit an appendage onto the paper unless given the permission to draw right onto the paper placemat. Start with the front arms by drawing two circles for shoulder sockets on each side of the mouth. Then draw circle pads for the front legs on the lower half of the paper: four on the bottom left and four on the bottom right. Draw a wavy line around the finger pads. Using straight lines, connect the shoulder socket to the finger pads as shown in the photo.

For the back of the frog, draw two lines: one starts above the shoulder and curves off the top of the paper. The other curves off the side. Add a few padded toes to the top half of the paper. Most likely there won't be much room for anything else. Add any patterns or details inside the frog's body.

Use one color of liquid watercolor paint and paint the entire background. To help children paint evenly, demonstrate how to trace around an area slowly and then fill in the center quickly. Work from top to bottom or side to side. Because the drawing is done with an oil pastel, it is very easy for most children to paint areas of color without the paint running together.

While the paint is still wet, sprinkle table salt on the paint. As the watercolor dries, the salt pulls the water toward it, leaving a small starburst effect. The salting technique generally works best on watercolor paper with translucent watercolors.

Next, select a color palette for the frog using pan watercolors. You can use the color wheel to pick colors that are beside each other (red, orange, yellow) or even across from or complementary to each other (blue and orange).

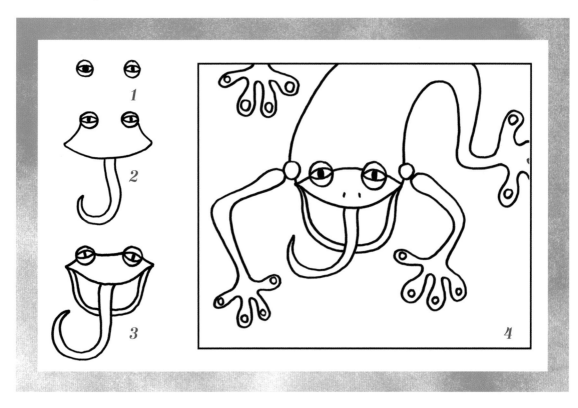

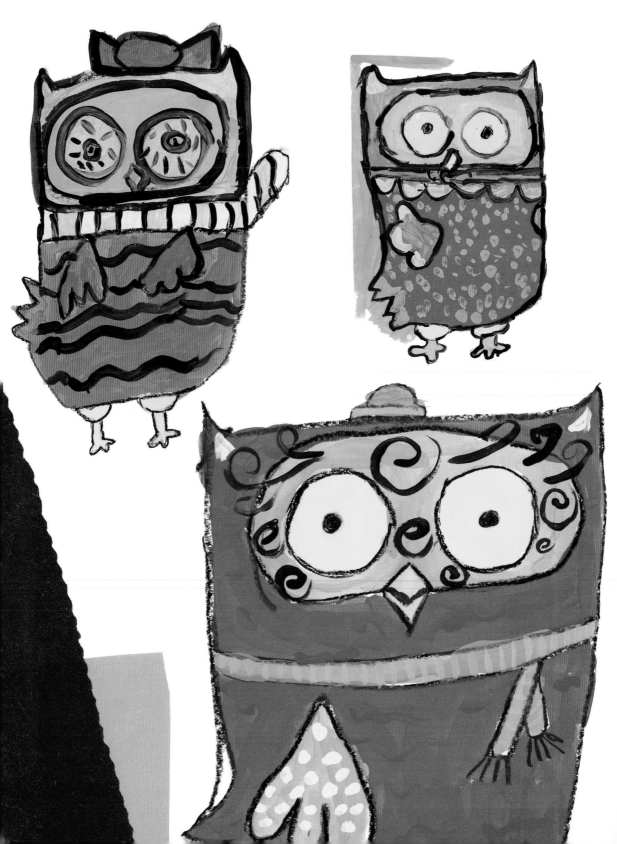

WHIMSICAL OWL

Drawing an animal with big eyes usually ends up being a favorite for kids. There is something about owls, especially in today's pop culture, that is particularly appealing. This project offers a few drawing options and strategies so that even the youngest artist can draw an owl.

THE SETUP

We used small plastic condiment cups, pre-mixed liquid tempera paint, and regular drawing paper to make this colorful owl.

THE PROCESS

Guide children in drawing the owl. Start by tracing a small condiment cup near the top of the paper for two eyes. Leave a space between the eyes and a bit of room at the top for the head. Don't add any details to the eyes yet.

Draw a diamond shape in the middle space below the eyes for the beak. Place the oil pastel next to one side of the diamond beak, and draw an oval shape around the eyes and back to the other side of the beak. Place the oil pastel above the eyes and draw a straight horizontal line for the top the head. Extend the line up on both ends to form small ears. From one ear, draw a line that goes down the side of the paper and curves around the bottom. Place the oil pastel on the other ear and draw a line down the side of the paper, gradually moving toward the middle so you'll have room for a tail. Connect the lines at the bottom. Draw two curved bumps below the body and draw the legs from these bumps. Add one wing in the center of the body.

what you'll need

- 1 sheet of 12" x 18" white drawing paper
- Black oil pastel
- Liquid tempera paints or acrylic craft paints in a variety of colors
- Medium brush
- Water and paper towels
- Plastic condiment cups

what you'll learn

- How to use a directed line drawing to achieve different results
- How to draw and paint details on dry paint

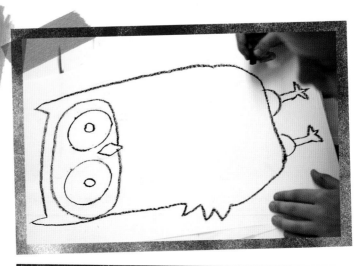

Place tubs of liquid tempera or acrylic paint on the tables or have kids select their own colors. By now, you probably have a stack of paints in plastic containers on your shelf. This is the perfect project to use them.

Paint the body, eyes, and wing first. Paint the background or leave it blank. After the base coat of paint has dried to a tacky finish, use a small brush and add details to the owl with either black or colored paint. Consider adding stripes, dots, feathers, and other decorative lines. It's important not to use too much water when cleaning your brush and switching colors. In fact, if you remove the water from the table,

and place small brushes inside the color paint containers, the children can select the paint color and start painting with the appropriate brush. When they are done, place the brush back into the color.

To define the owl and make the colors pop, use a small brush and black paint to outline the details. If the painting is completely dry, you can use an oil pastel or even a broad-tip marker to add details.

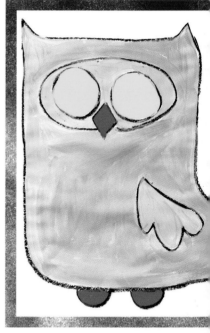

tip

Be careful using markers on damp paint as the paint often ruins the markers. So make sure to wait until the paint is completely dry if markers are your outlining tools of choice.

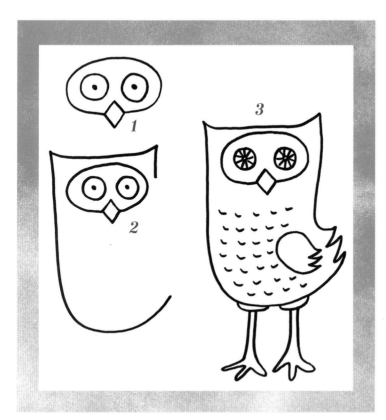

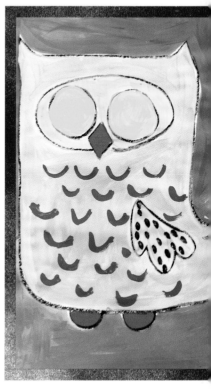

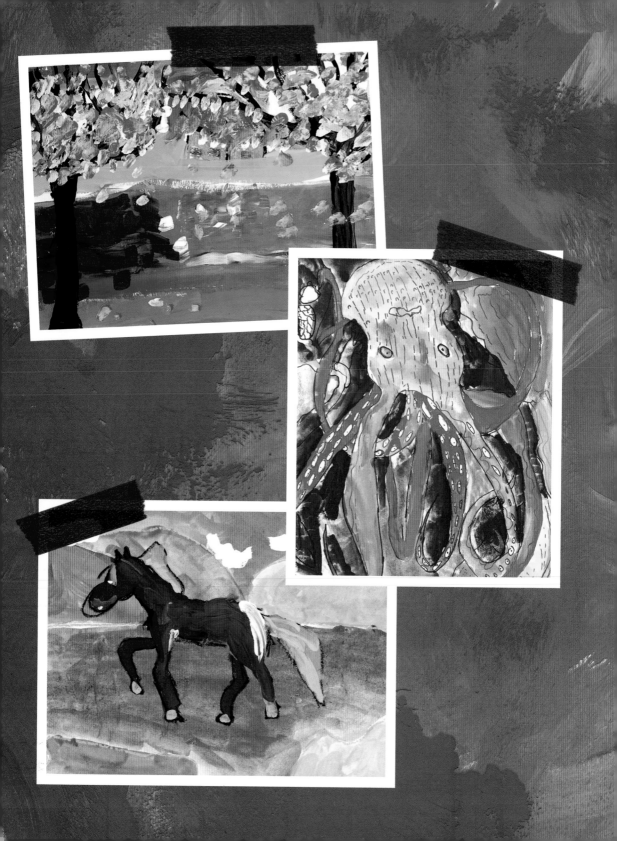

ACKNOWLEDGMENTS

Teaching art in the Goleta Union School District was one of the biggest joys of my life. Walking into my art room each day and introducing techniques, mediums, and artists to my students was the best job this girl could have. Thank you to Ed Armstrong, Bob Wood, and Lynette Myer for hiring me to teach art at your schools. You took a chance with me and I'm so thankful you did.

I want to thank all my workshop artists for their time and energy. They brought fun, expression, and life to all of the projects. I couldn't have asked for a better group of kids to work with. A big thanks to Jaden Barker, Ona Caballero, Toby Caballero, Victoria Chow, Bailey Conway, Reagan Conway, Sadie Dent, Sophie Dent, Sarah Dent, Dominic DeRosa, Nico DeRosa, Joe DeRosa, Jamie Hetrick, Malia Hetrick, Ryan Hill, Lake Hillyer, Carson Iza, Malcolm Iza, Ayden Kateb, Caden LaPlante, Avery Leck, Fallyn Lee, Huxley McGetrick, Sierra Moore, London Moro, Claire Nelson, Jennifer Nelson, Michelle Nelson, Ava Paloczi, Charlotte Paloczi, Milo Porter, Cole Racich, Erika Rasmussen, Michael Reyes, Robert Reyes, Emmylou Sanchez, Liam Shea, Wynona Shea, Julianne Steelsmith, Rio Valle, Emie Valle, Garrett Williams, and Noah Wood. Without all of you, this book wouldn't exist! And a BIG thanks to all the parents for allowing your children to be a part of this book.

Special thanks to Shannon (Team Sparkle!) for spending hours coordinating the children's schedules in order to complete the projects in this book.

Working with an agent and creating an actual book proposal was a dream come true. Thanks to Erica Rand Silverman who reached out and offered to help. Erica's passion, direction, and energy helped me rethink how this book could serve parents and children in the best possible way.

To have the opportunity to work with an editor like Jennifer Urban-Brown was an absolute joy. Writing a book is not a solo endeavor. A team is involved and Jennifer was a great leader. She even made deadlines fun.

To my best friend, business partner, and husband, Neil. You are my rock. Thank you for supporting and encouraging my crazy ideas. I love being on this journey with you.

And finally, to all my Sparklers . . . you bring joy to kids all over the world through your art-making genius. Thank you for your constant support and encouragement, not just for me, but for each other. Art teachers have the best job in the world!

RESOURCES

One of the first steps in making great art with kids is to use quality art supplies. And it can be really simple: multipurpose paper, a few paint choices, a black waterproof marker, and some oil pastels. These supplies are available through various online retailers like Blick, Discount School Supply, and Amazon. Don't forget to visit www.drawpaintsparkle.com/resources for video demonstrations on my favorite art supplies and to download a PDF of my favorite art supplies.

DRAWING AND PAINTING PAPER

• Pacon Tru-Ray Sulphite Drawing Paper (76-lb white 12" x 18" paper)

PAINTS

• Crayola Premium liquid tempera paints, Faber-Castell liquid tempera paints, Connector paints (cake tempera)

• Crayola or Prang semi-moist watercolor sets

• Blick liquid watercolor paints, Sargent Art liquid watercolor paints

PASTELS

• Faber-Castell oil pastels (both water soluble and non-soluble), Pentel oil pastels, Sakura Cray-Pas oil pastels

• Sargent Art square chalk pastels, Faber-Castell chalk pastels, Alphacolor chalk pastels

MARKERS

• Broad-tip markers (Faber-Castell broad-tip and Crayola washable markers) for younger kids, and Prismacolor markers for older students

• Sharpie black fine-point markers for drawing

PAINTBRUSHES

• Royal Langnickel Big Kid's Choice brush sets (flat and round)

• Richeson Utility brush sets (for painted paper projects) or any big handle and big brush for small hands

PICTURE BOOKS I LOVE FEATURING THE ARTISTS IN THIS BOOK

- On Vincent Van Gogh: *Camille and the Sunflowers* by Laurence Anholt, Barron's Educational Series, 1994.

- On Henri Rousseau: *The Fantastic Jungles of Henri Rousseau* by Michelle Markel and illustrated by Amanda Hall, Eerdmans Books for Young Readers, 2012.

- On Maud Lewis: *Capturing Joy: The Story of Maud Lewis* by Jo Ellen Bogart and illustrated by Mark Lang, Tundra Books, 2011.

- On Franz Marc: *The Artist Who Painted a Blue Horse* by Eric Carle, Philomel Books, 2013.

- On Claude Monet: *The Garden of Monsieur Monet* by Pia Valentinis and illustrated by Giancarlo Ascari, Royal Academy Publications, 2015.

- On Clementine Hunter: *Art from Her Heart: Folk Artist Clementine Hunter* by Kathy Whitehead and illustrated by Shane W. Evans, G.P. Putnam's Sons Books for Young Readers, 2008.

- On Jackson Pollock: *Action Jackson* by Jan Greenberg and Sandra Jordan and illustrated by Robert Andrew Parker, Square Fish, 2007.

INSPIRING ART BOOKS FOR CHILDREN

- *Beautiful Oops!* by Barney Saltzberg, Workman Publishing Company, 2010.

- Books by Peter Reynolds (*The Dot*, *Ish*, *Sky Color*), Candlewick, 2003.

- *The Color-Play Coloring Book* by Pascal Estellon for The Museum of Modern Art online bookstore.

Patty Palmer taught elementary school art in Goleta, California, for twelve years before trading in her paint-splattered apron to help teachers teach art to kids. Through her website, www.deepspacesparkle.com, Patty offers insight into what it's like to teach art inside a classroom through video tutorials, lesson plans, and art resources. Her membership site, the *Sparklers Members Club*, a community of over three thousand teachers, is dedicated to providing art lesson bundles, curriculums, and teaching resources for art teachers. Every summer, Patty and Team Sparkle host a sold-out art workshop for teachers in Goleta, California.

Before teaching art, Patty's early years were spent drawing and painting in her farmhouse bedroom in Prince Edward Island, dreaming of ways she could spend her life creating art.

She lives in Santa Barbara with her husband and business partner, Neil. Together they have three kids, Newt, Tate, and Elliott, who are on their way to creating their own amazing lives.

Connect with Patty through Facebook, Instagram, and YouTube via *Deep Space Sparkle*.